Jan. 2, 2023

My beautiful niece

Monica, Happy New Year!

As you know, I was raised Buddhist, and also attended Catholic mass on Sundays growing up.

(p. 11) Thich Nhat Hanh was a prolific Buddhist, p. 72 teacher. I have found comfort in Buddhist practice as well as Catholic mass. Could it be because I have twin (hybrid?) (Ahh, yes!) Your singing bowl was so comforting to me while in Chicago.

You are a blessing in my life! Your singing bowl meditation in Chicago.

there is so much love in you, there is someone on this planet who will cherish you as their life partner.

All my love,
Auntie Amanda

21, 52, 62, 70, 74, 82, 88, 95, 116, 123, p. 154

A WAY OF LIFE

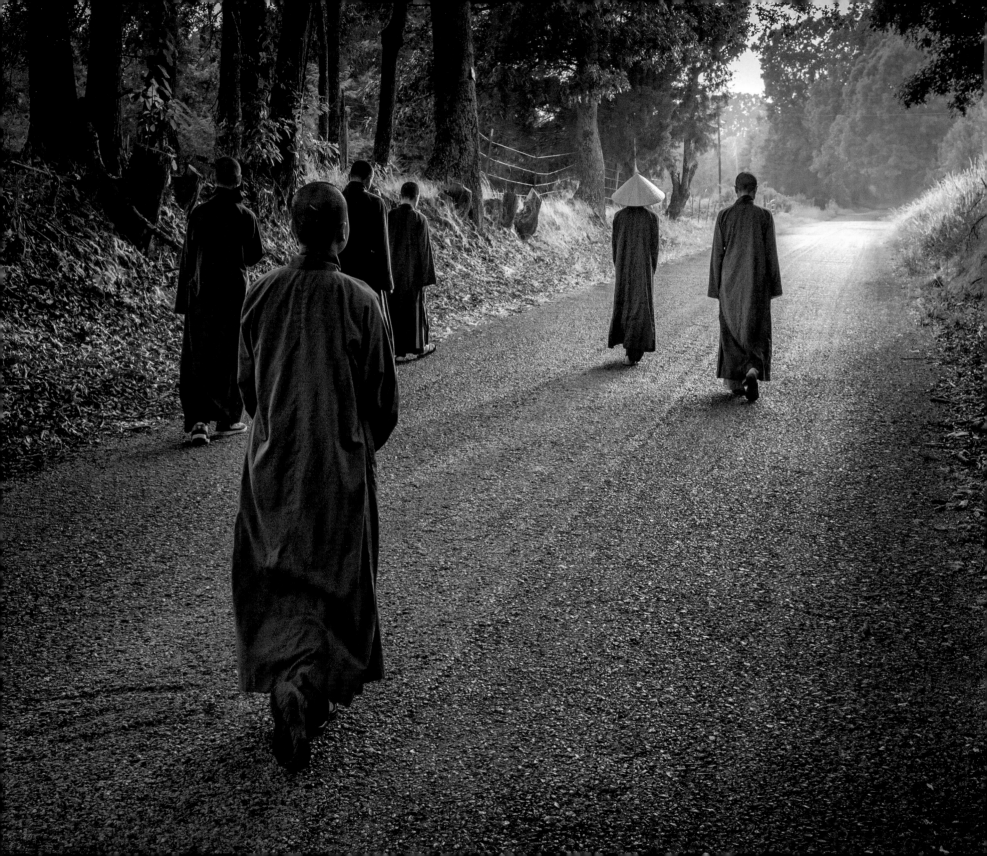

A WAY OF LIFE

ZEN MONASTICS AT WORK AND PLAY

..

PAUL DAVIS

WITH QUOTATIONS BY
THICH NHAT HANH

**PARALLAX
PRESS**

BERKELEY, CALIFORNIA

*In gratitude to Thich Nhat Hanh, the Fourfold Sangha, and
my family, who have guided and supported me on my journey.*

Parallax Press
P.O. Box 7355
Berkeley, California 94707
parallax.org

Parallax Press is the publishing division of
Unified Buddhist Church, Inc.
© 2017 Paul Davis
All rights reserved
Printed in Canada

Cover and text design by Debbie Berne
Author photograph Wil Maxton

Every effort has been made to locate and obtain
permission from each person featured in the book.
Photographs were taken with the knowledge of the
subjects. If anyone wishes to have their photo removed
during a future printing, please contact the publisher.

ISBN: 978-1-941529-76-8

Library of Congress Cataloging-in-Publication Data is
available upon request.

1 2 3 4 5 / 21 20 19 18 17

MIX
Paper from
responsible sources
FSC® C016245
FSC
www.fsc.org

pages 93, 94, 130–133, 135: The joyful practice of the Plum
Village tradition is celebrated on special occasions, such as the
final evening of a retreat, or on holidays such as Tet, with skits,
music, poetry, and performances.

Cover photo: monks playing *da cau*, a popular Vietnamese sport
resembling hacky sack

If in our daily life we can smile,
if we can be peaceful and happy,
not only we, but everyone will profit from it.
This is the most basic kind of peace work.

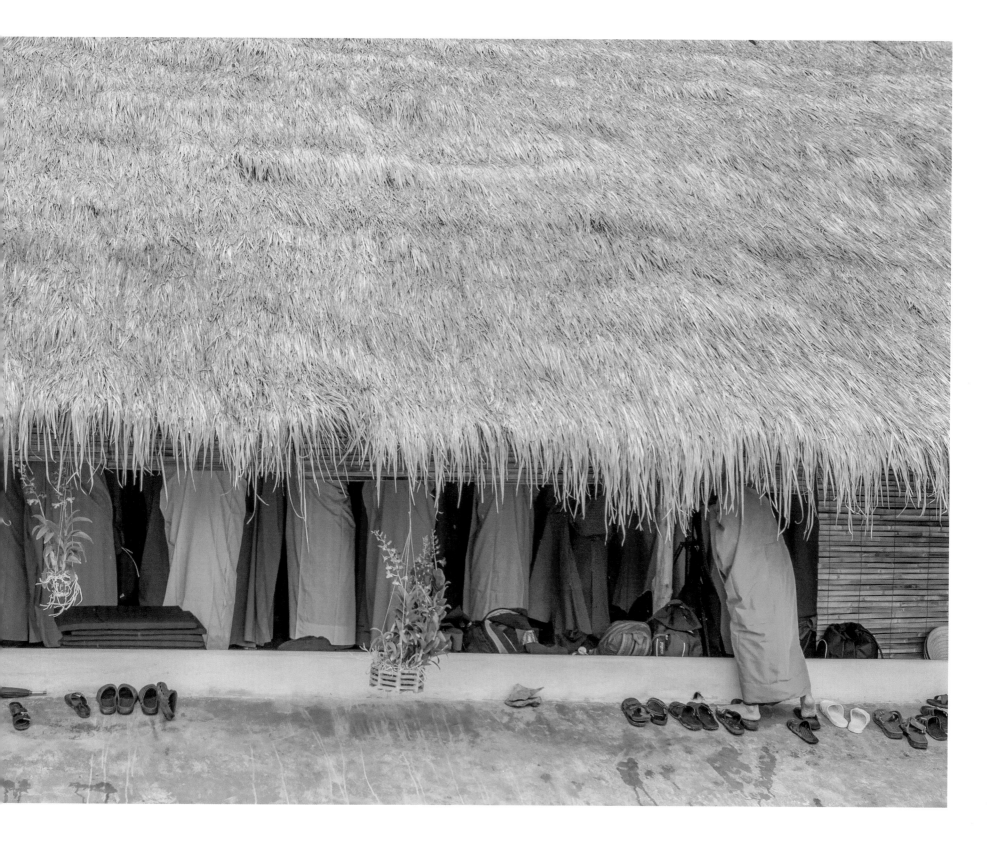

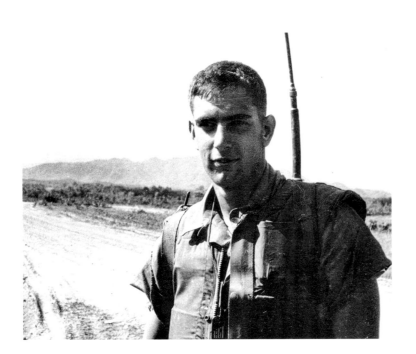

I FIRST CAME IN CONTACT WITH THICH NHAT HANH AND THE PLUM Village Buddhist monks and nuns in the early 1990s, soon after the death of my youngest son, Nathan. He was seventeen, a senior in high school. On December 23, Nathan had been at our house with some friends wrapping Christmas presents. When they finished, they left to take one of the friends home. Driving the car was a sixteen-year-old who had just gotten her driver's license. They went over a railroad crossing too fast and the car went airborne. Nathan was the only one killed. Several days after Christmas, I opened his present. It was *Happy Trails*, a collection of Berkeley Breathed's *Bloom County* comic strips.

After Nathan's death, I entered a period of reflection unlike anything I had experienced. I was searching without expecting to find answers. In Thich Nhat Hanh's Zen teachings, I didn't find canned answers, but I did find a life path that made sense to me and a belief system that asked nothing of me except to be aware of and validate my own experience.

My connection to Thich Nhat Hanh (Thay, as his students call him) actually goes much further back. Growing up in rural Ohio in the 1950s, I was sheltered from the reality of war. Then, at nineteen, I went as a Marine to Vietnam, knowing little about life and nothing about the Vietnamese people and culture.

My journey has been, and continues to be, a practice of letting go of old beliefs and allowing deeper insights to emerge. My first lesson on letting go came in 1967. About a year after returning to the United States, and while I was still in the Marine Corps, I had an opportunity to talk to a college class about Vietnam. The discussion was more about the culture than the war. At the end of the formal presentation, I was asked if I thought the people of Vietnam wanted us there. I gave a long, rambling answer. After I spoke, the person who had asked the question said, "You didn't really answer my question." I had not. At that moment, the world as I knew it started to dissolve.

I started replaying my experiences in Vietnam and began to let go of the filters that had blocked my uncomfortable experiences from entering my consciousness. With these filters gone, a new reality began to emerge.

I still feel the intensity of one encounter from 1966. While sitting by the road in a rural area of Vietnam about twenty miles from the coastal city of Da Nang, I had a conversation with a young girl I'll call An, which is Vietnamese for "peace." An spoke a good amount of English, and it was easy to talk with her. At one point in our conversation she asked me why I was in Vietnam. I said something like, "We are here to protect you from the Vietcong and the Communists." Without hesitation, she replied, "No. If you go home, we will be okay." At that time, I discounted her and her beliefs; after all, she was only a child. I thought she just didn't understand. The reality was that I was also a child, and I didn't understand.

My memory of her is that she was wise, kind, and strong. I don't know if she survived the war. Much later, after I had gone to college, was raising a family, and had started to practice mindfulness meditation, I wrote this poem for An, and for me.

AN

Marine, why are you in my country?
You tell me you are here to save me.
I don't believe you.
Marine, you are not listening to me.
I don't hate you and your eyes tell me
you don't hate me.
Marine, why are you in my country?
Open your eyes. What keeps my words
from reaching your heart?
Why did you kill me?
Why did I kill you?
I died before you knew me.
You died before you understood.
Come to me—open your heart. I will hold you
and you will know me
and understand.

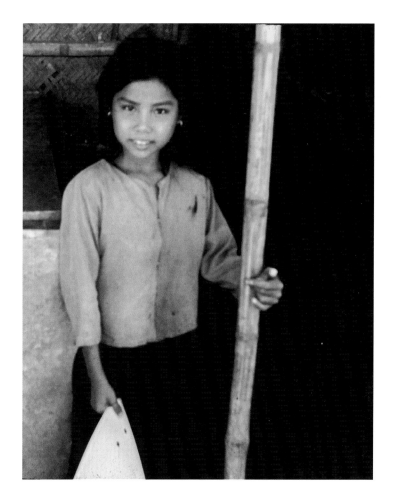

The original version of *An* referenced the Vietnam Veterans Memorial in Washington, DC: "Meet me at the wall. I will hold you and you will know me and understand." The more I understood how we are all connected, the more I realized I had focused only on the American deaths. Three to five million Vietnamese people, from both the north and south, died during the war.

Thich Nhat Hanh and I both left Vietnam in 1966. My first trip back to Vietnam was in 2003. Nhat Hanh returned in 2005 after a long and

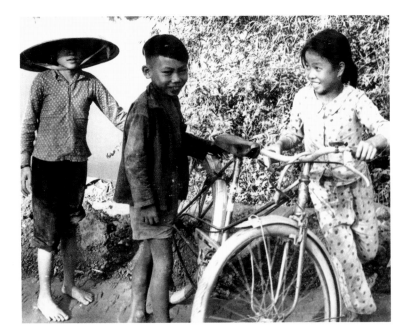

The precepts embody the core teachings of compassion and social justice. The first precept is: "Aware of the suffering created by fanaticism and intolerance, we are determined not to be idolatrous about or bound to any doctrine, theory, or ideology, even Buddhist ones. Buddhist teachings are guiding means to help us learn to look deeply and to develop our understanding and compassion. They are not doctrines to fight, kill, or die for." This precept continues to be my guiding light.

My interest in photography began in 1965, when I first arrived in Vietnam and bought a 35mm rangefinder camera. I had the camera with me every day until I was wounded and taken out of the country on January 23, 1966. The photos I took were in the middle of a war, but they are not typical war photos. I felt connected to the children I met there, and they were the primary subjects. I do not know if any of the children in my photos survived the war. The war went on so long they would have had to choose between the Communists or Anti-Communists. Staying neutral was not an option.

It wasn't until 2003, when I returned to Vietnam, that I became more serious about photography. My passion for photography and deepening my understanding of Zen teachings happened at the same time. I found the decisive moment—a snapshot of time that would quickly come and go—and the mindful moment, to be a solid foundation for my photographic journey. With mindful awareness of what was around me I could see more clearly what was emerging. My best photos come from being in a quiet space free from attachments to what is a good photo.

As I began to spend more time with Thich Nhat Hanh and the monks and nuns practicing in the Plum Village tradition, I made a conscious decision to focus my photography on the full diversity, joy, and compassion of the community. *Sangha* is a Sanskrit word that means "inseparable" and denotes a community dedicated to practicing mindfulness and compassion together.

However, this one photo of Thich Nhat Hanh, on the facing page, was particularly auspicious. In 2008, I took a photo of Thay as he was walking through the gates of Tu Hieu Pagoda in Hue, Vietnam. Tu Hieu is his root

complicated negotiation with the Vietnamese government. At that time, Vietnam wanted to show it was opening up on religious freedom, so it was anxious for him to return. One of Thich Nhat Hanh's requirements was that he be allowed to travel with a group of nuns and monks and with one hundred lay followers. I was fortunate to be a member of the delegation.

My second trip to Vietnam with Thich Nhat Hanh came in 2008. We were in Hanoi for a retreat and a United Nations conference on Engaged Buddhism. While in Hanoi, I was ordained in the Order of Interbeing, a lay and monastic order that Thay had started in 1966. The order was created to train and provide support for young social workers who were taking care of the casualties of war. Members of the Order of Interbeing navigated the difficult path of not taking sides while helping, staying engaged, and staying aware of the suffering people were experiencing. It is now a worldwide organization that agrees to follow fourteen key guidelines, called precepts.

temple. One of the nuns had borrowed my camera to walk the grounds of the pagoda and take some photos. I was happy for her to be with the camera and for me to just be. Later, as I was standing just inside Tu Hieu's main gate, she ran up to me and said, "Thay is coming through the gate just like he did when he was sixteen." She handed me the camera and I made a few quick changes to the camera settings. I looked up and took this picture. This photo is a reminder that often you don't select the photo; the photo selects you.

Initially, I felt that it was Thich Nhat Hanh and his teachings that directly supported me on my journey. Although I have been his student for over twenty years, I have never spoken one word directly to him. But over the years, it has been the monks and nuns who have always been available to me. Like me, many of them found the practice through deep suffering. Although the seeds of sadness are still present in them, they also intentionally nurture the seeds of joy. It is this joy, even during work, that I have observed and been inspired by. It is the joy that has been, and continues to be, the focus of my photographic journey.

Paul Davis
July 12, 2016

Paul Davis is a retired social worker, a documentary photographer, and a member of the Order of Interbeing. He leads the Being Peace Sangha, a Cincinnati community that practices in the tradition of Thich Nhat Hanh.

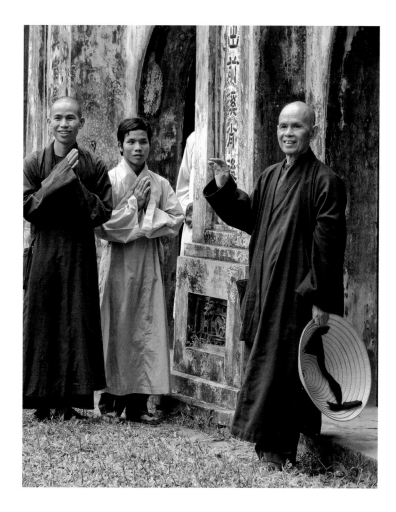

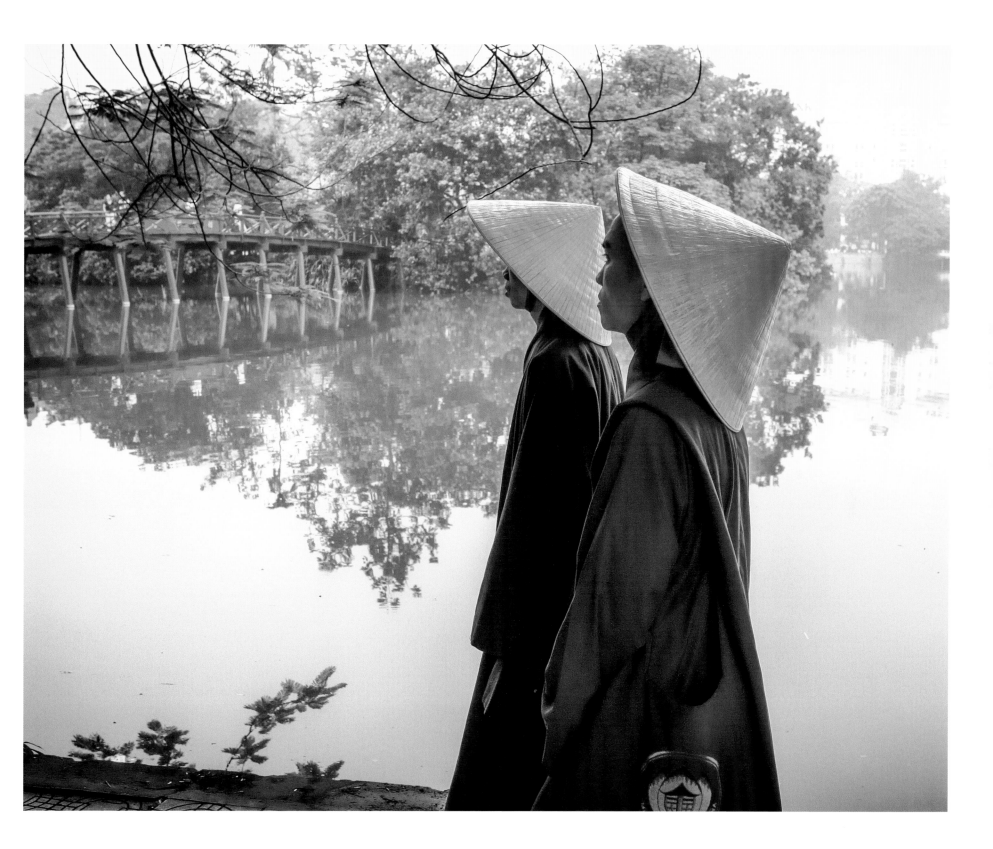

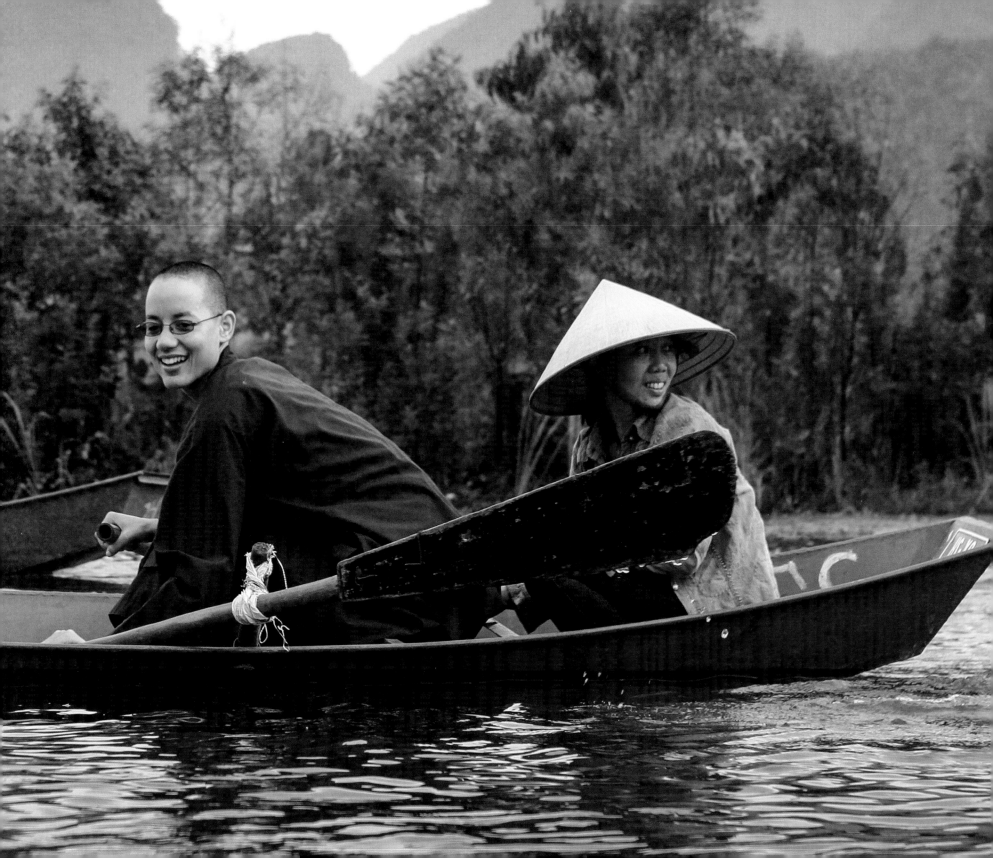

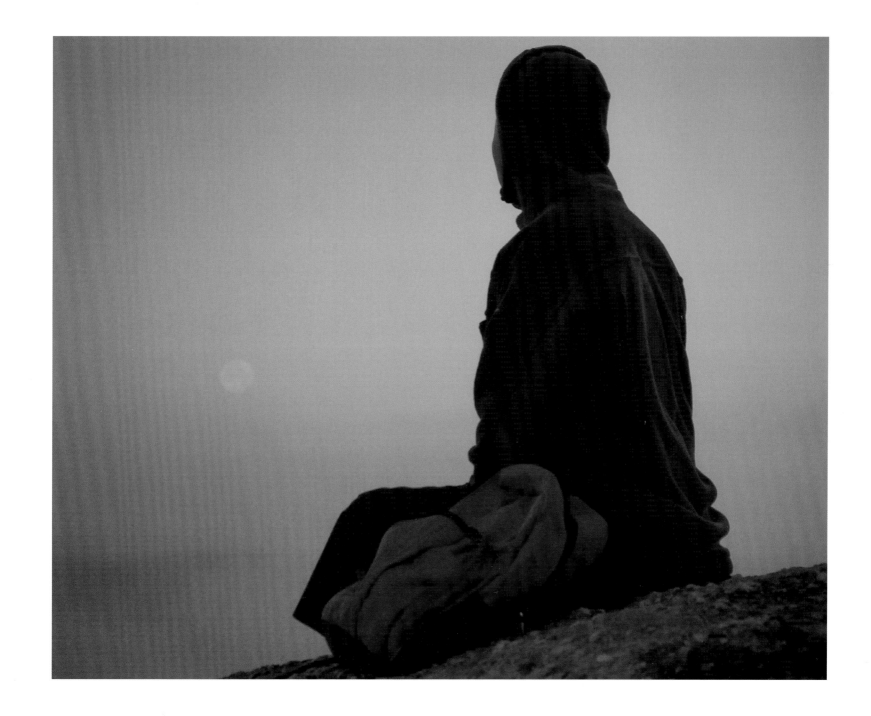

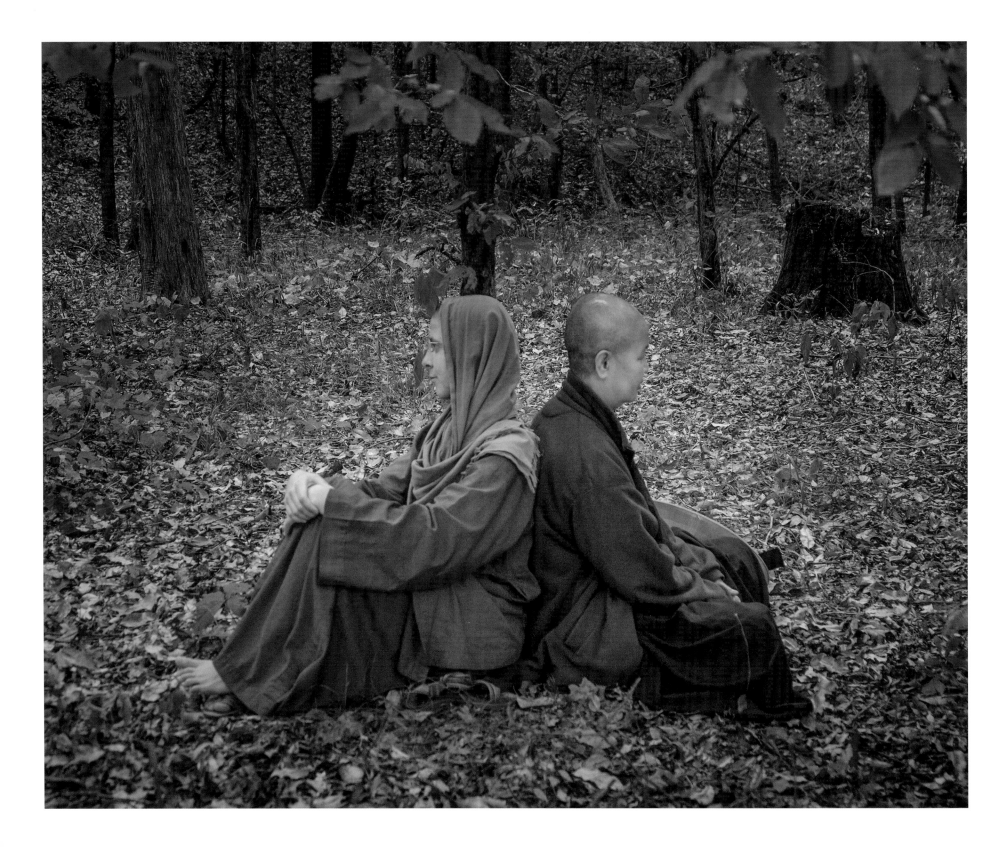

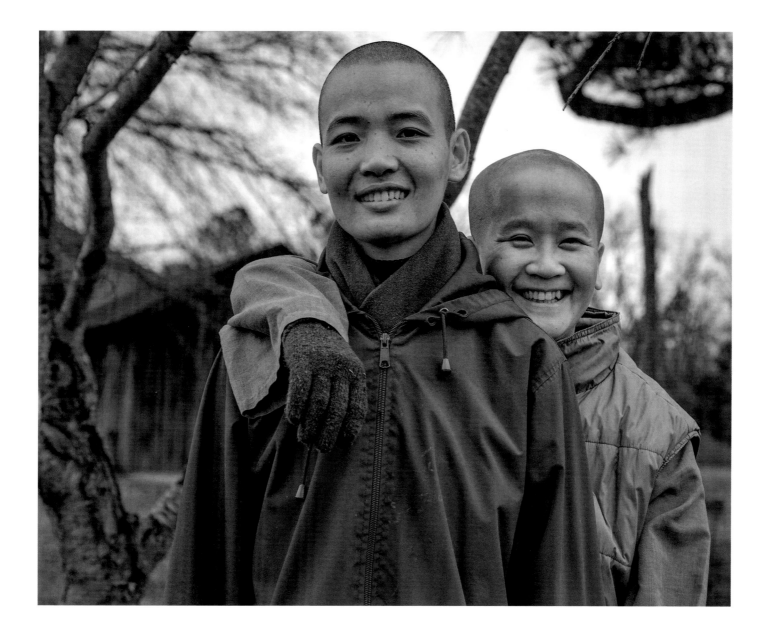

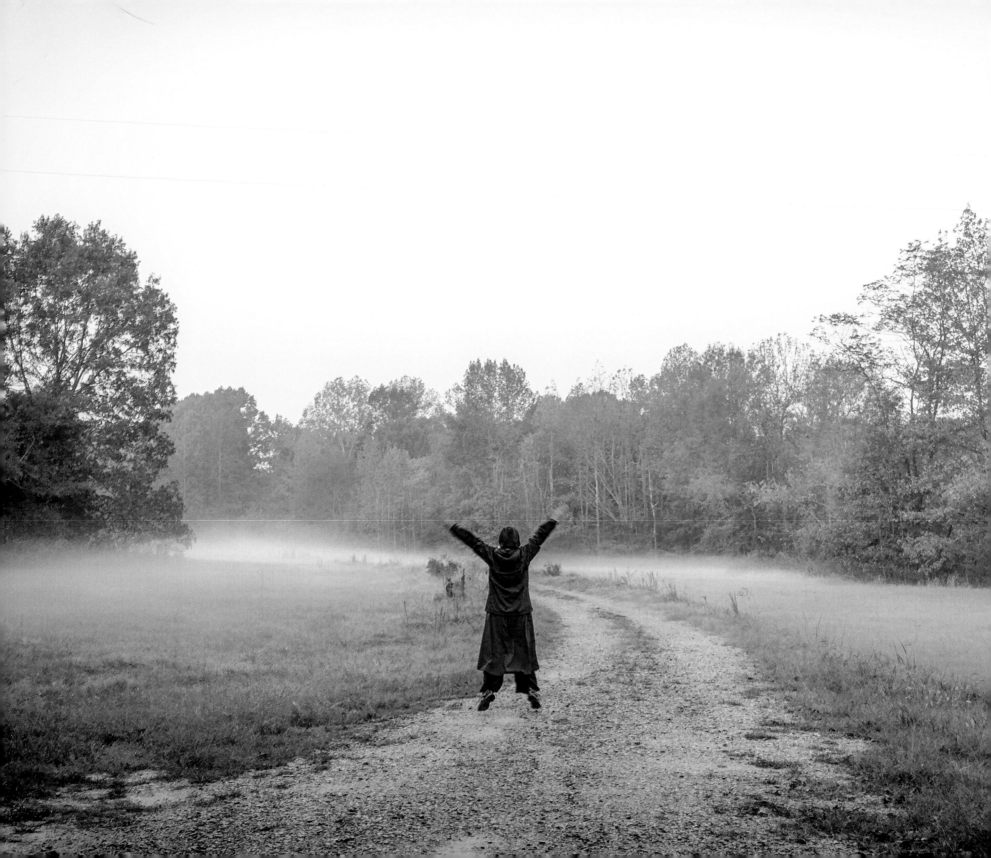

Waking up this morning, I smile.
Twenty-four brand new hours are before me.
I vow to live fully in each moment
and to look at all beings with eyes of compassion.

May our heart's garden of awakening bloom with hundreds of flowers.

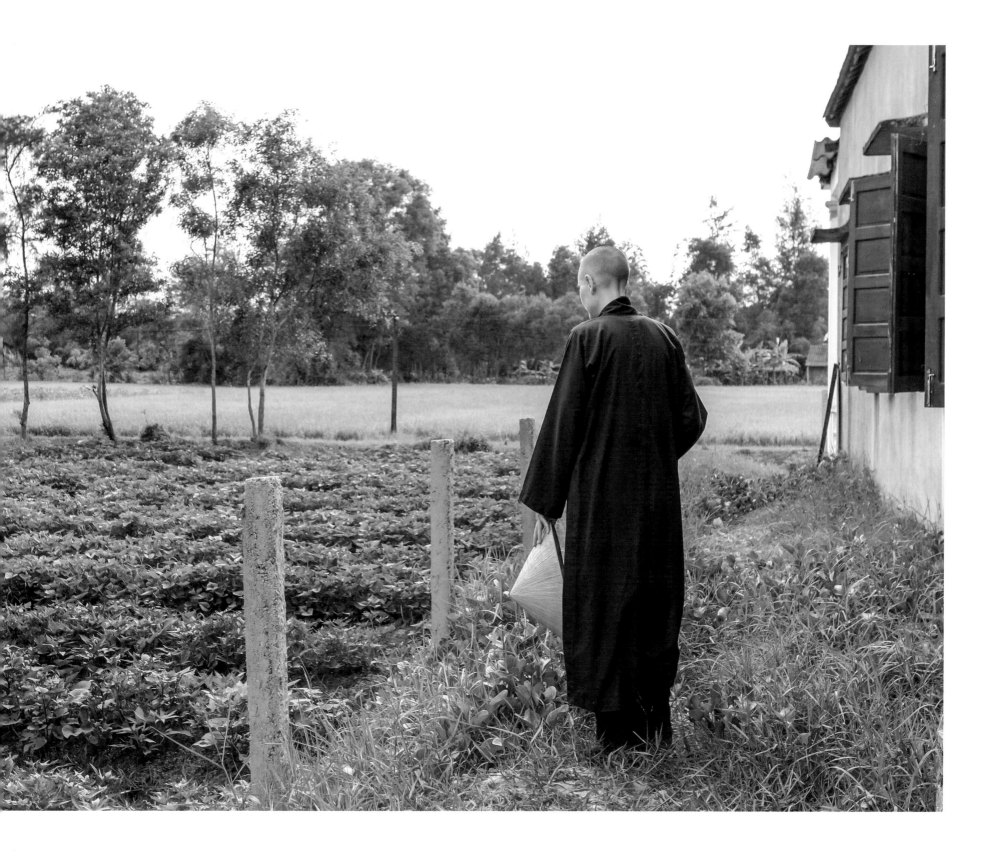

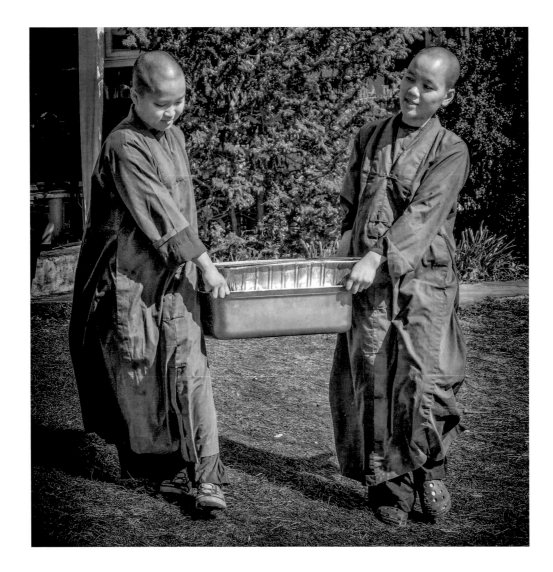

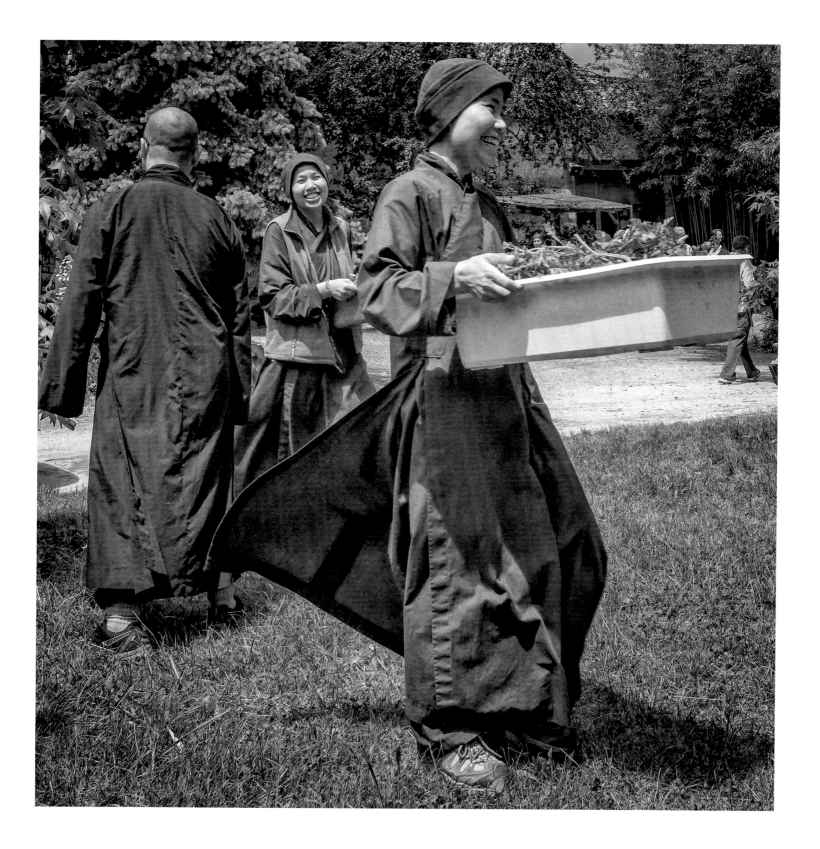

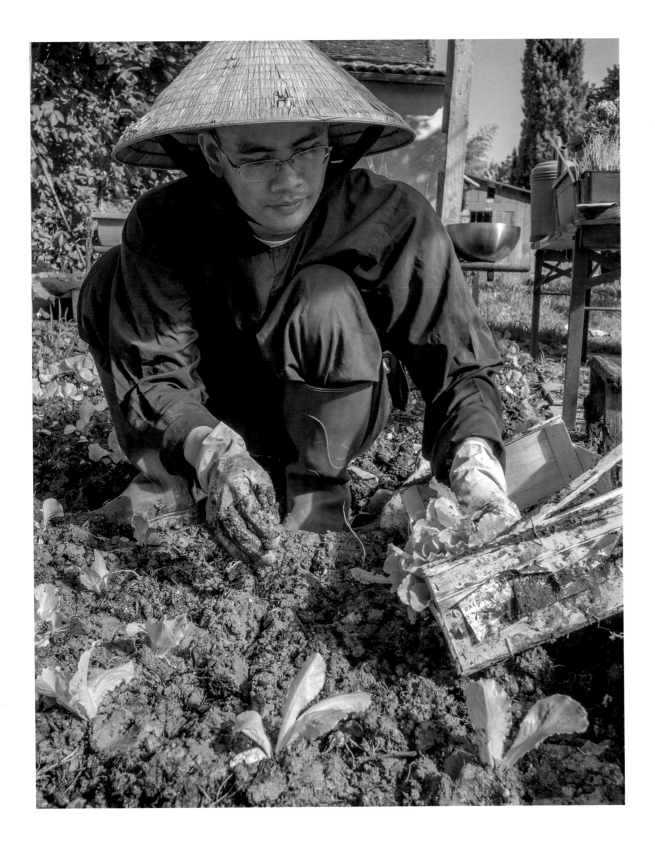

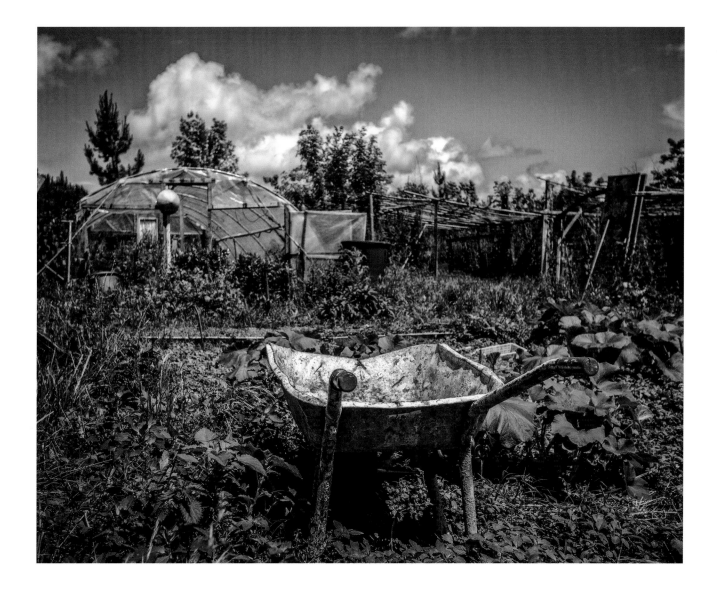

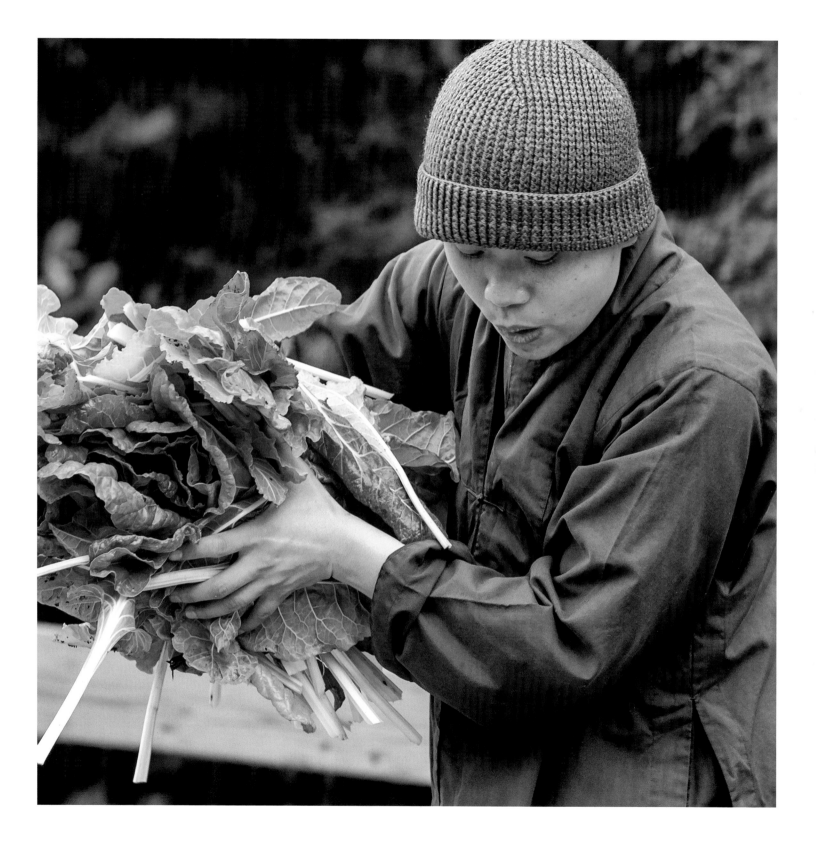

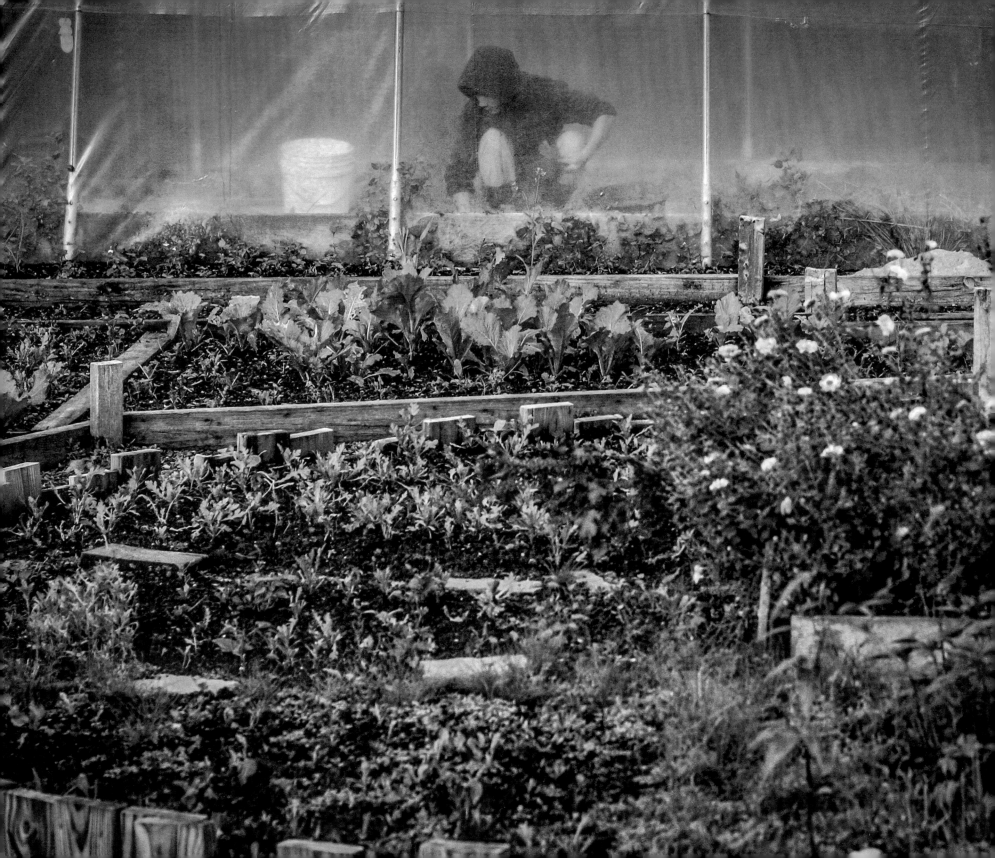

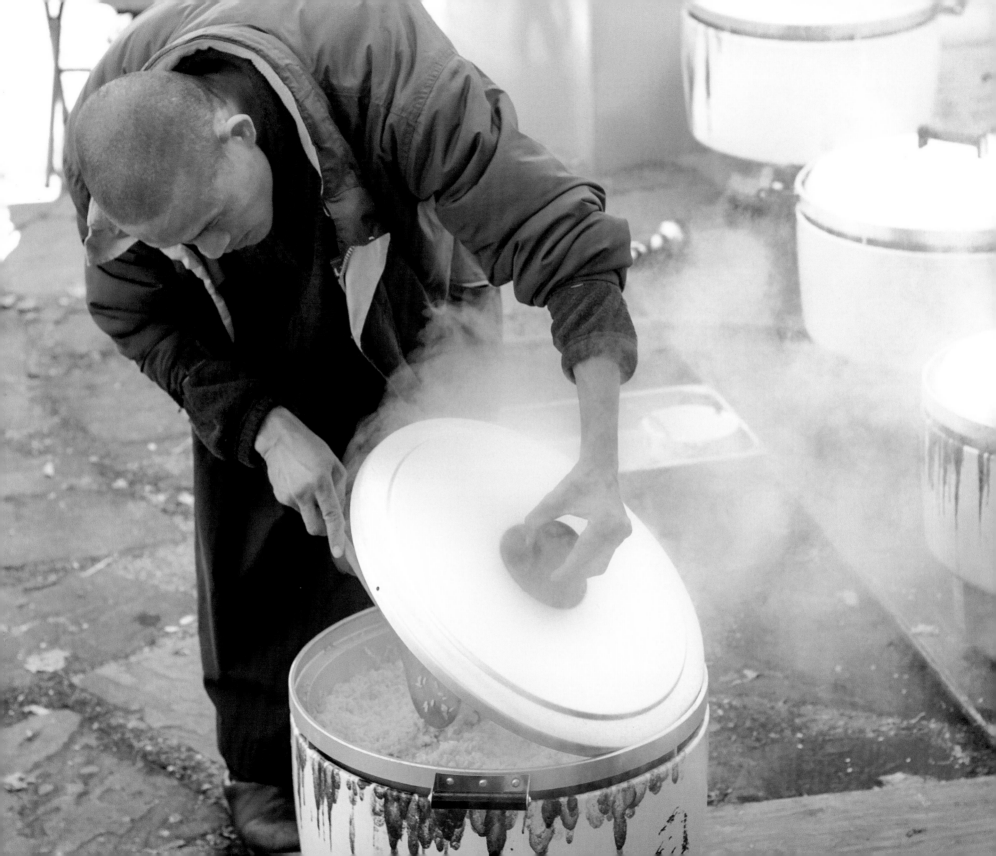

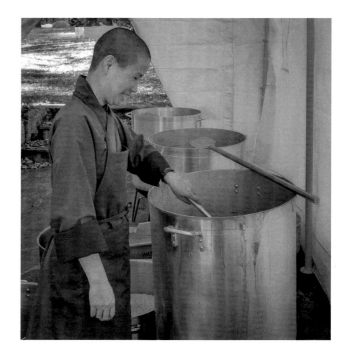

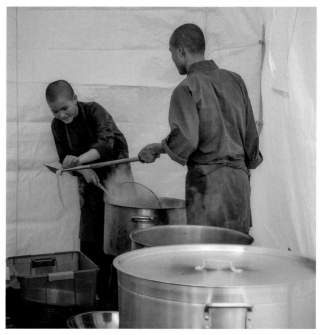

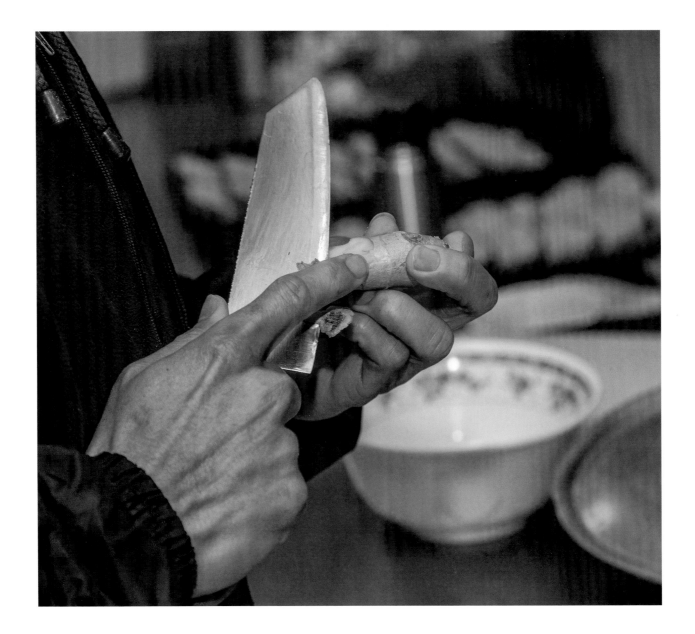

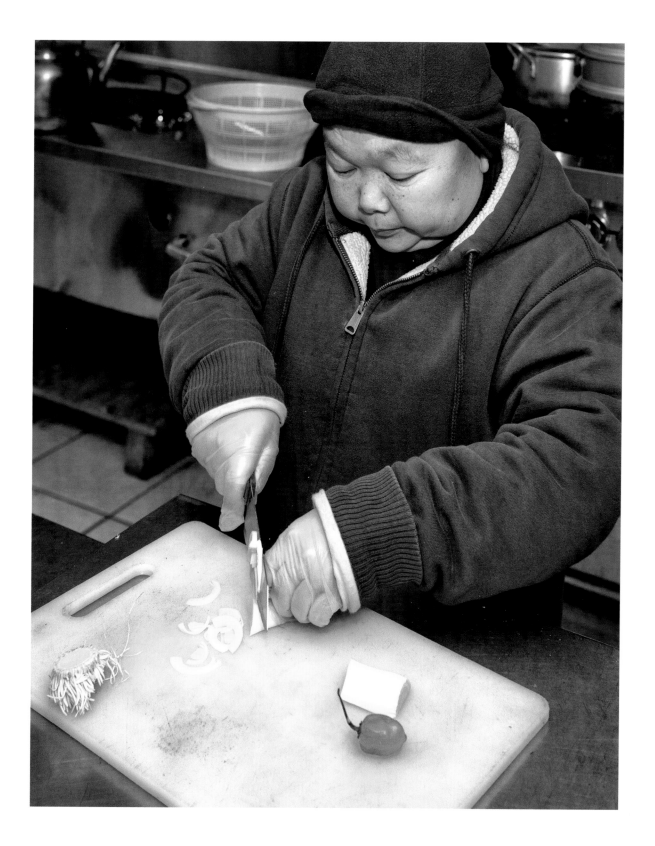

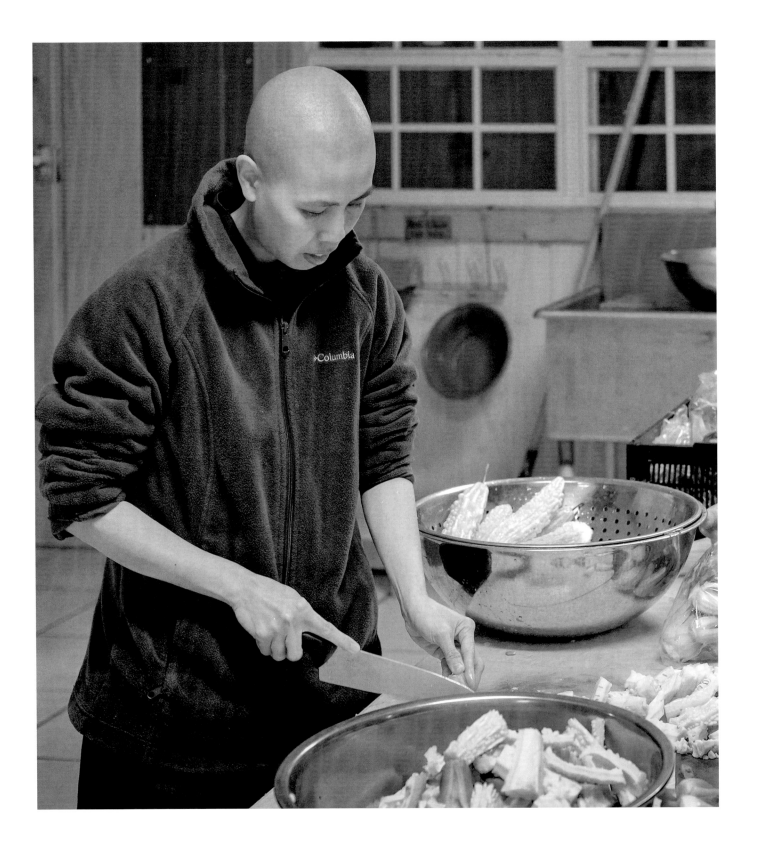

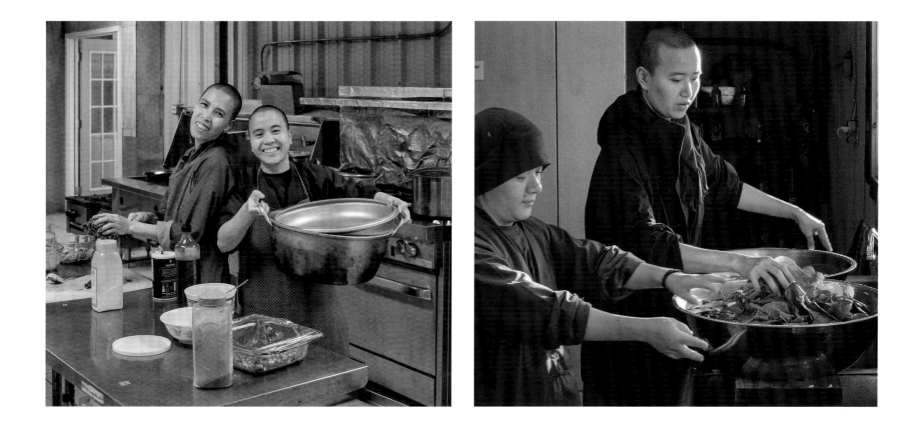

With the first taste, I promise to offer joy.

With the second, I promise to help relieve the suffering of others.

With the third, I promise to see others' joy as my own.

With the fourth, I promise to learn the way of nonattachment and equanimity.

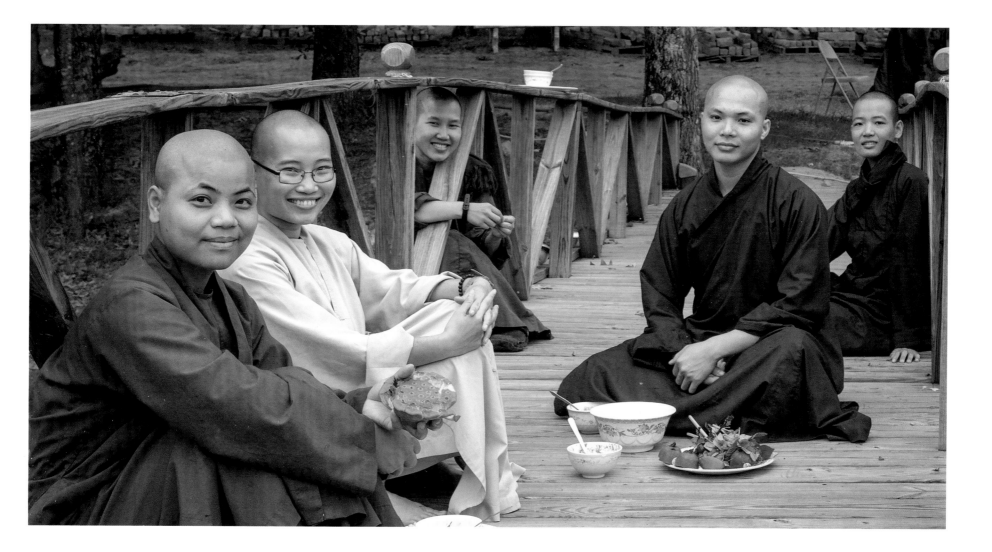

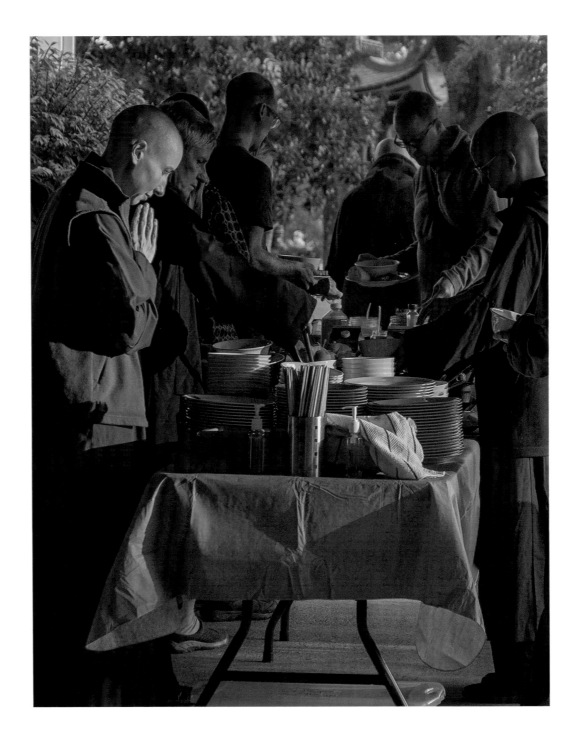

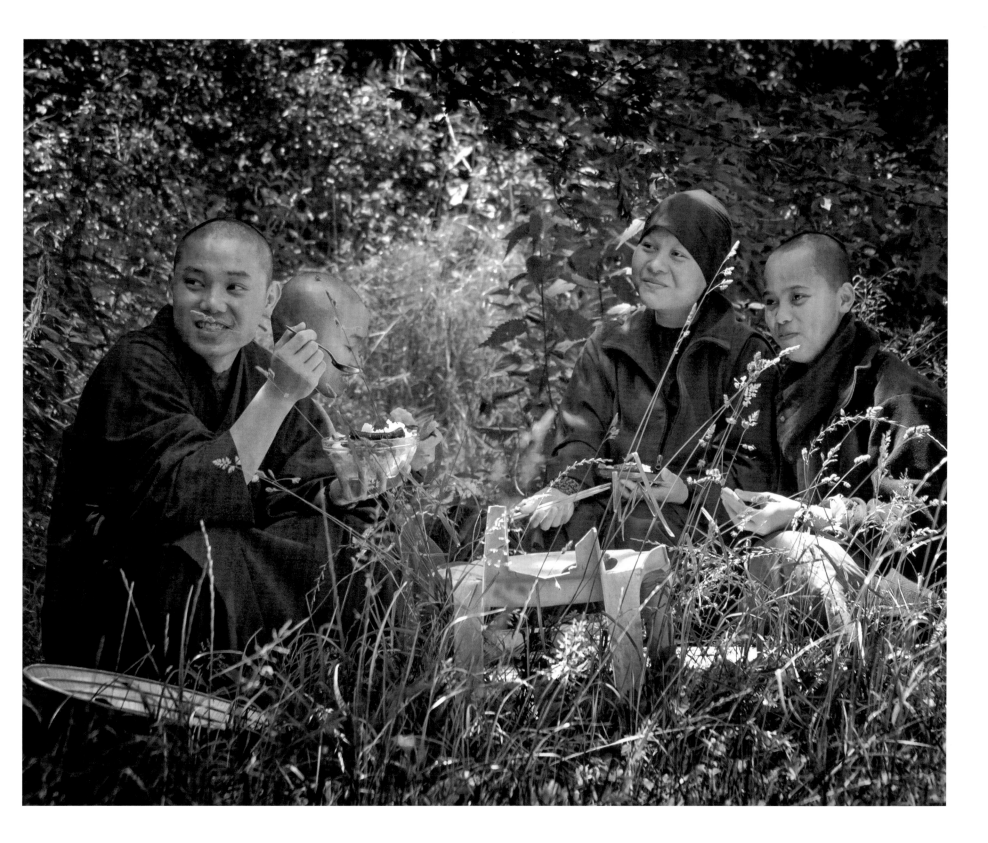

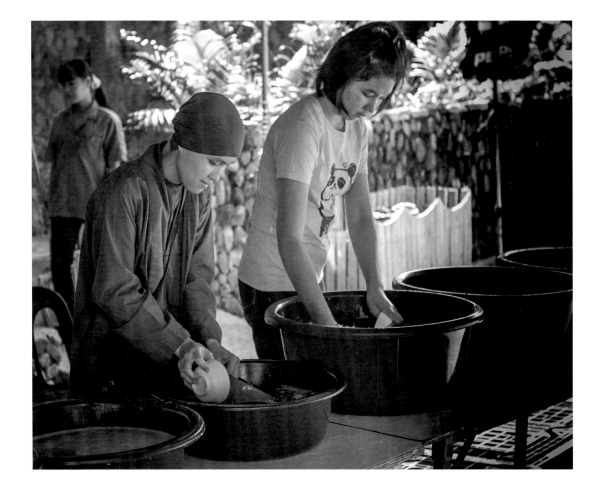

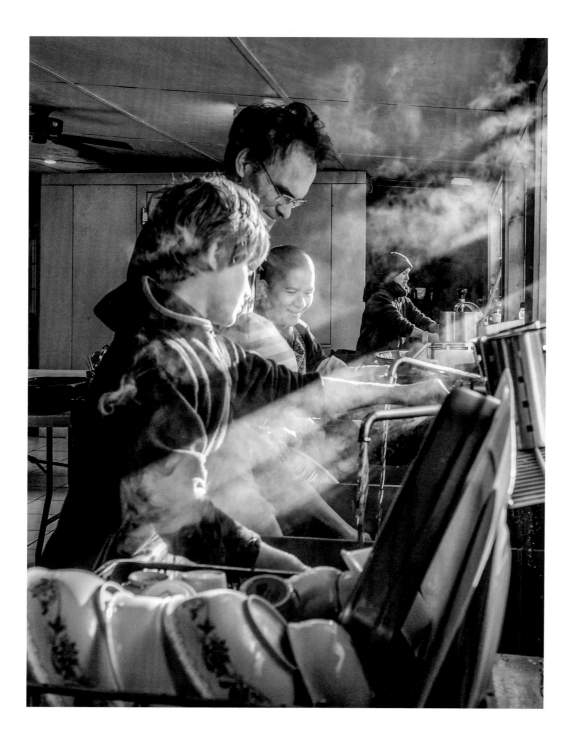

Washing the dishes
is like bathing a baby Buddha.
The profane is the sacred.
Everyday mind is Buddha's mind.

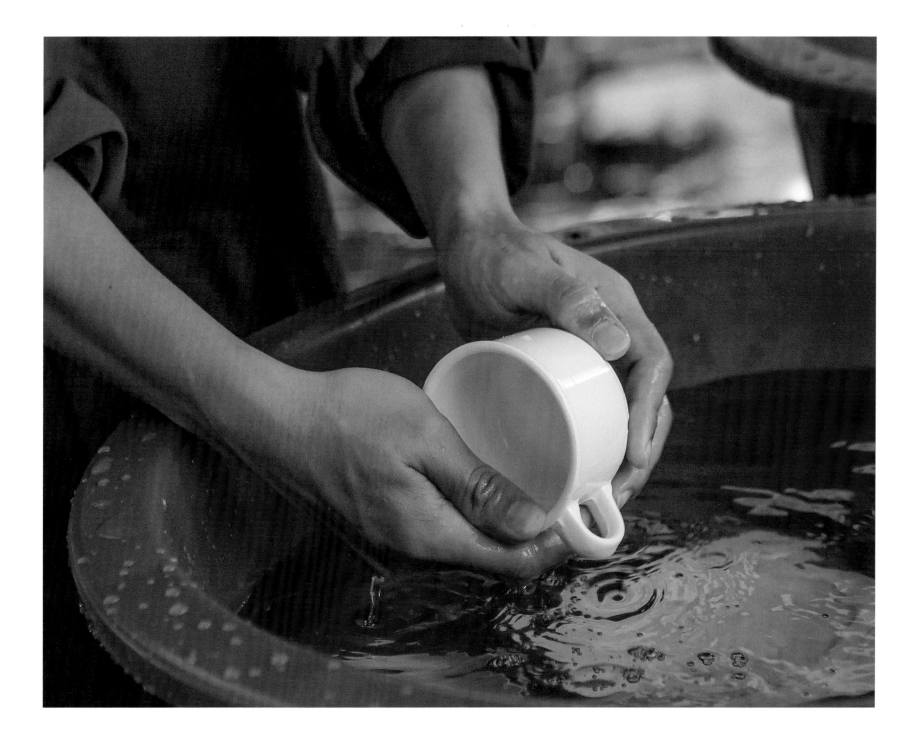

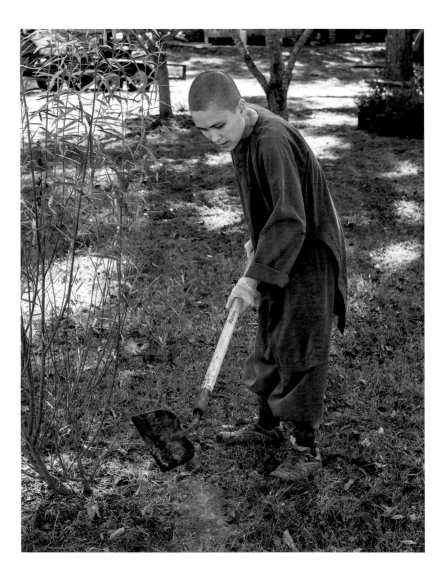
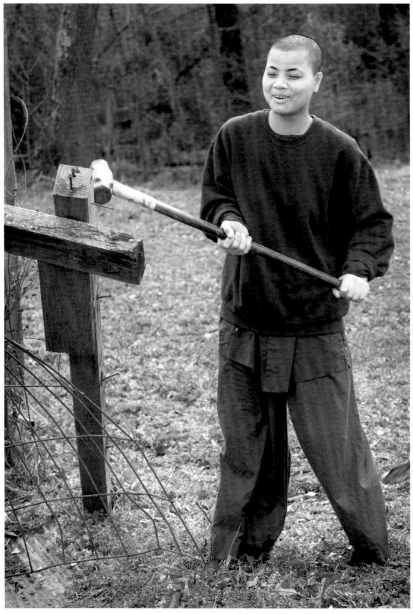

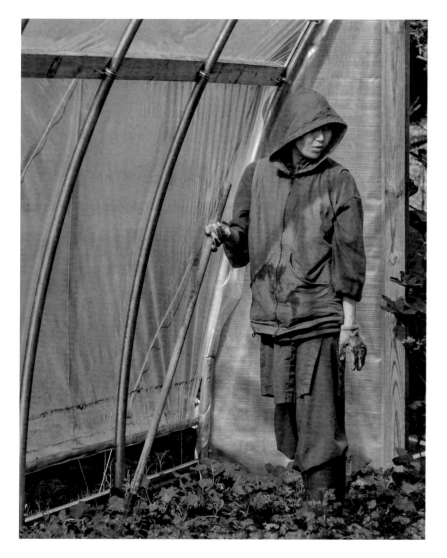
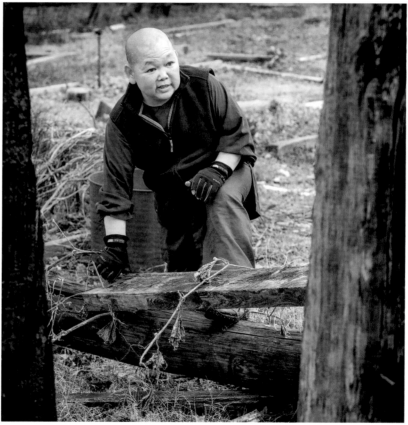

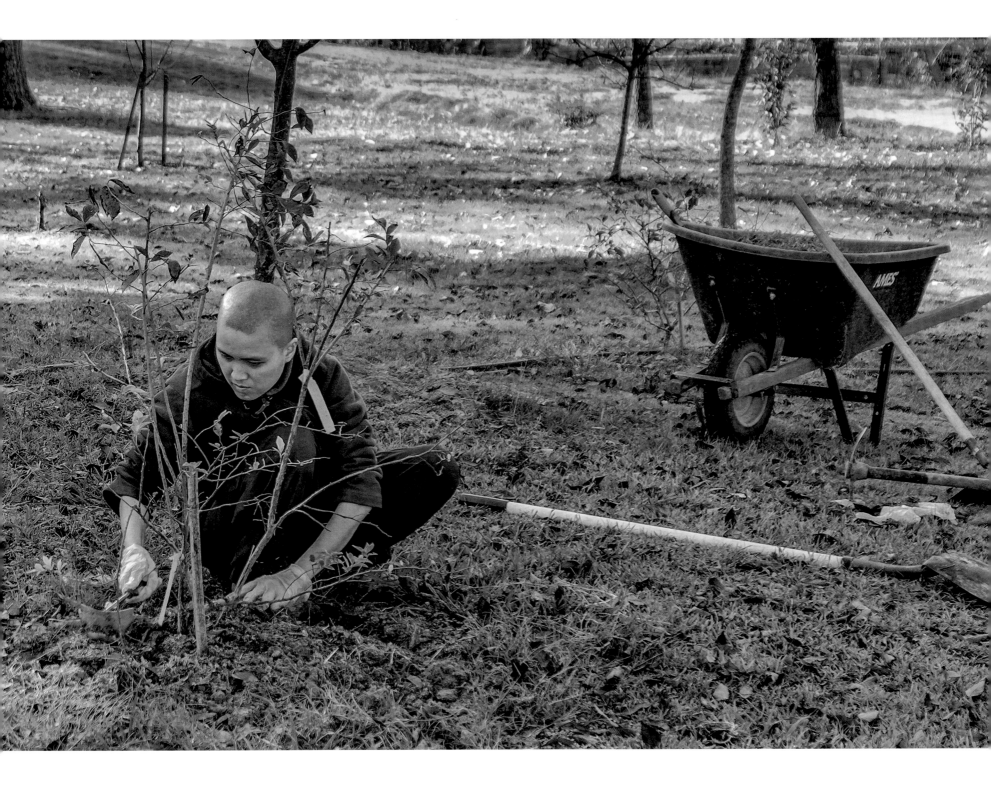

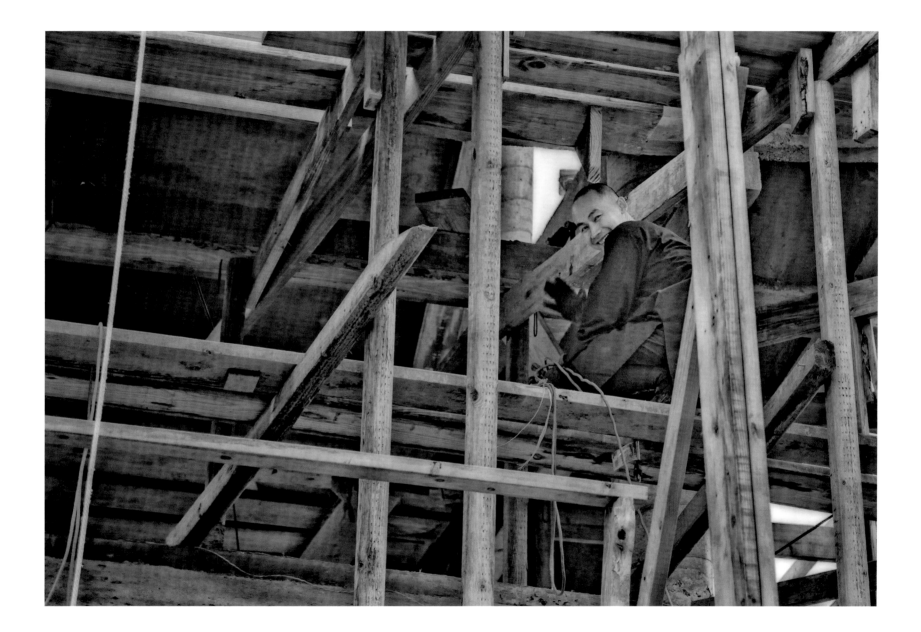

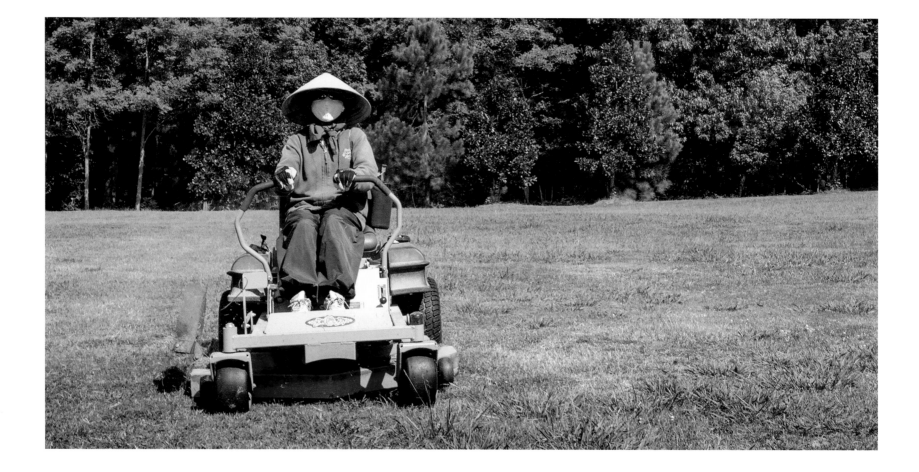

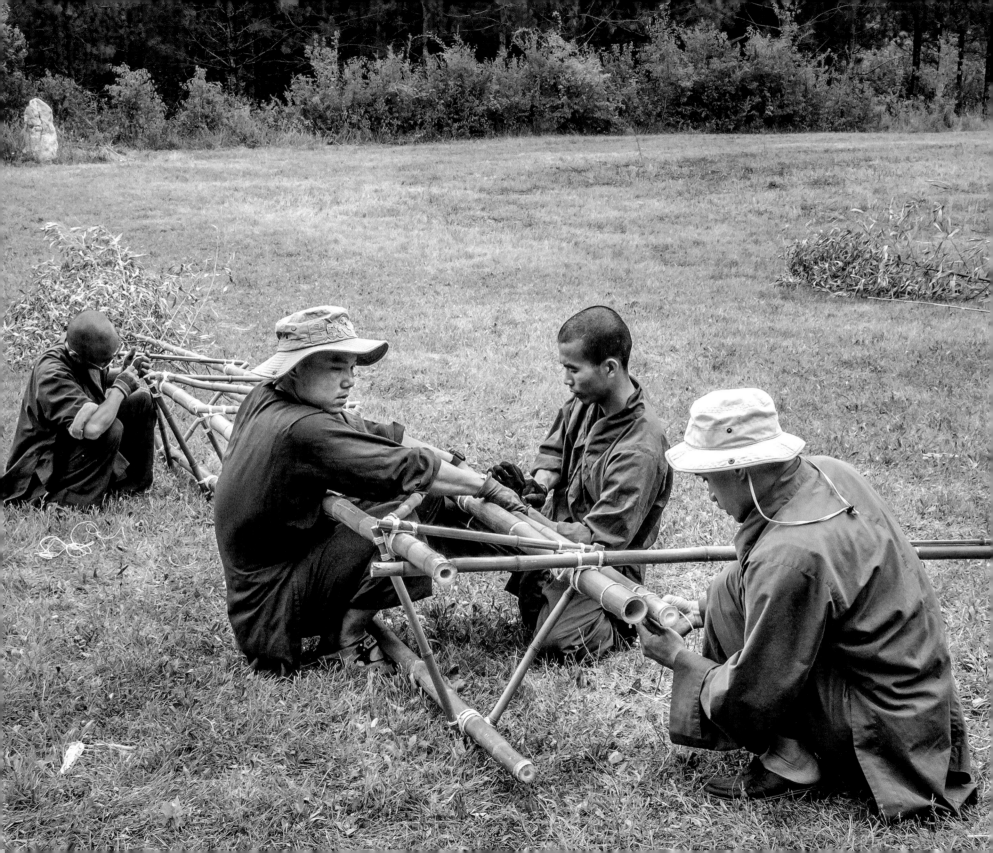

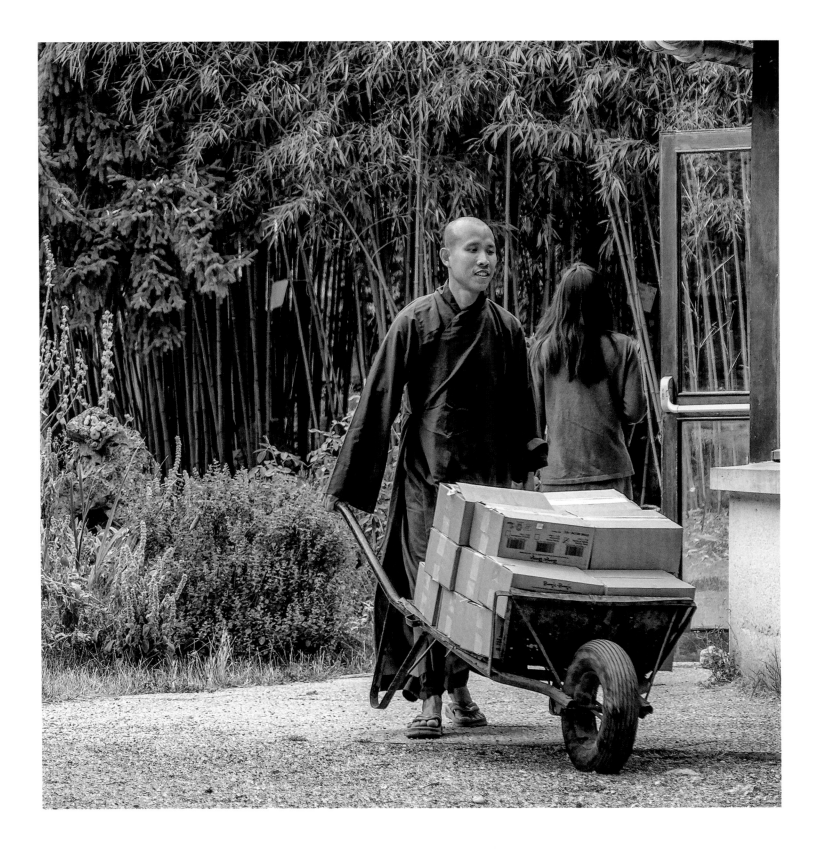

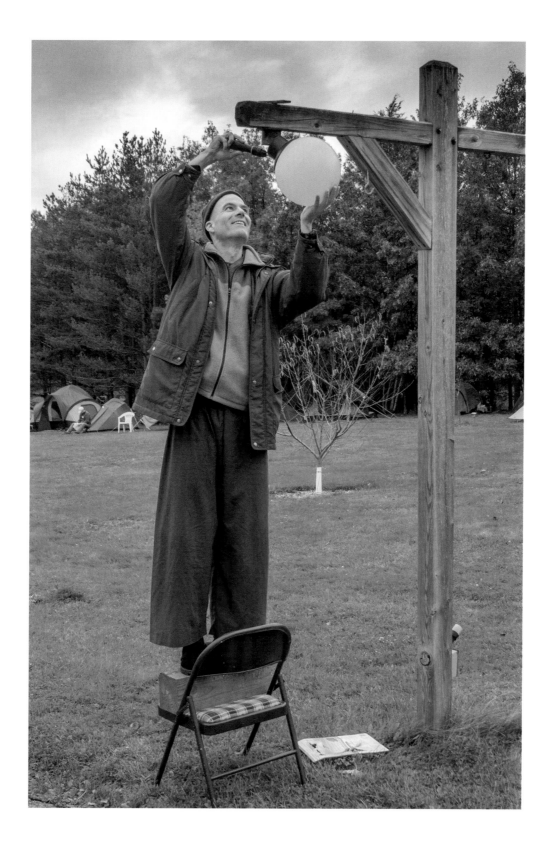

Peace is present right here and now,
in ourselves and in everything we do and see.
Every breath we take, every step we make
can be filled with peace, joy, and serenity.

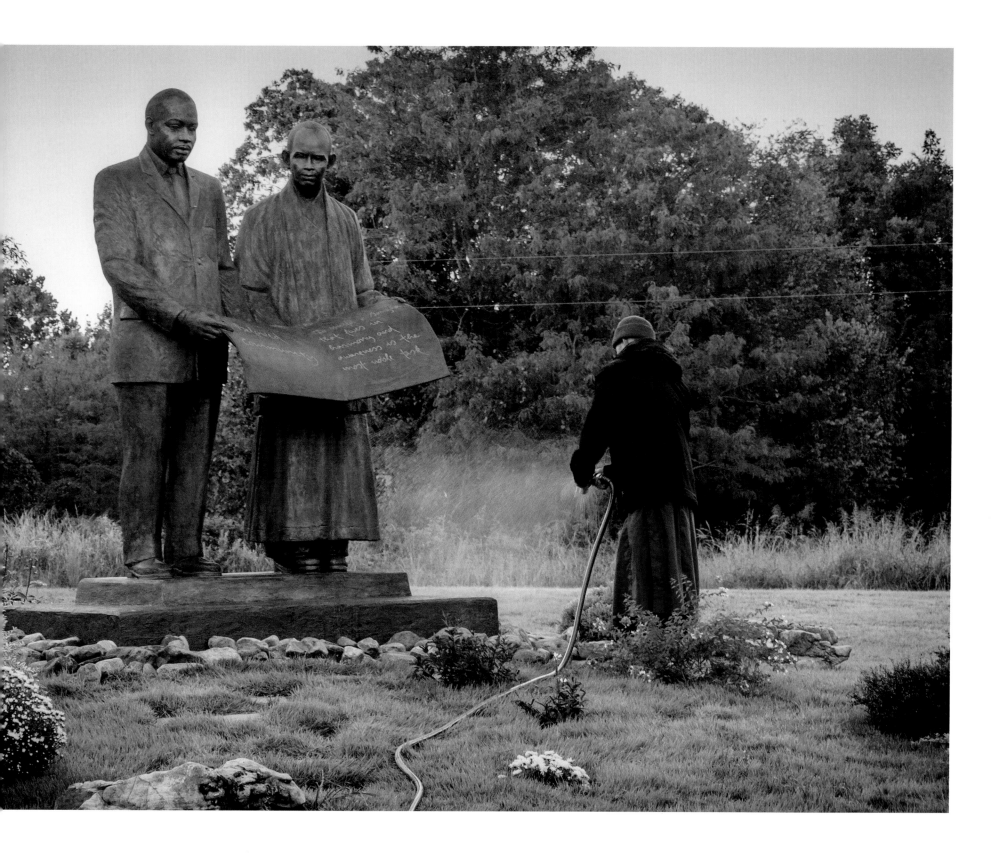

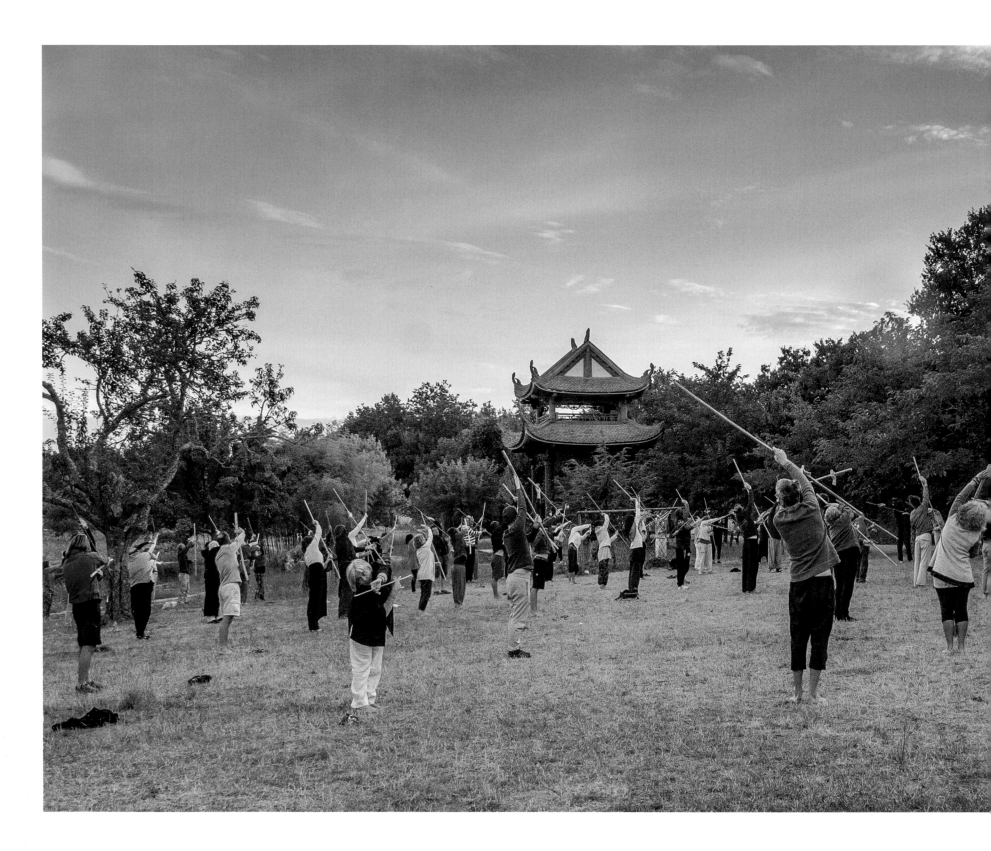

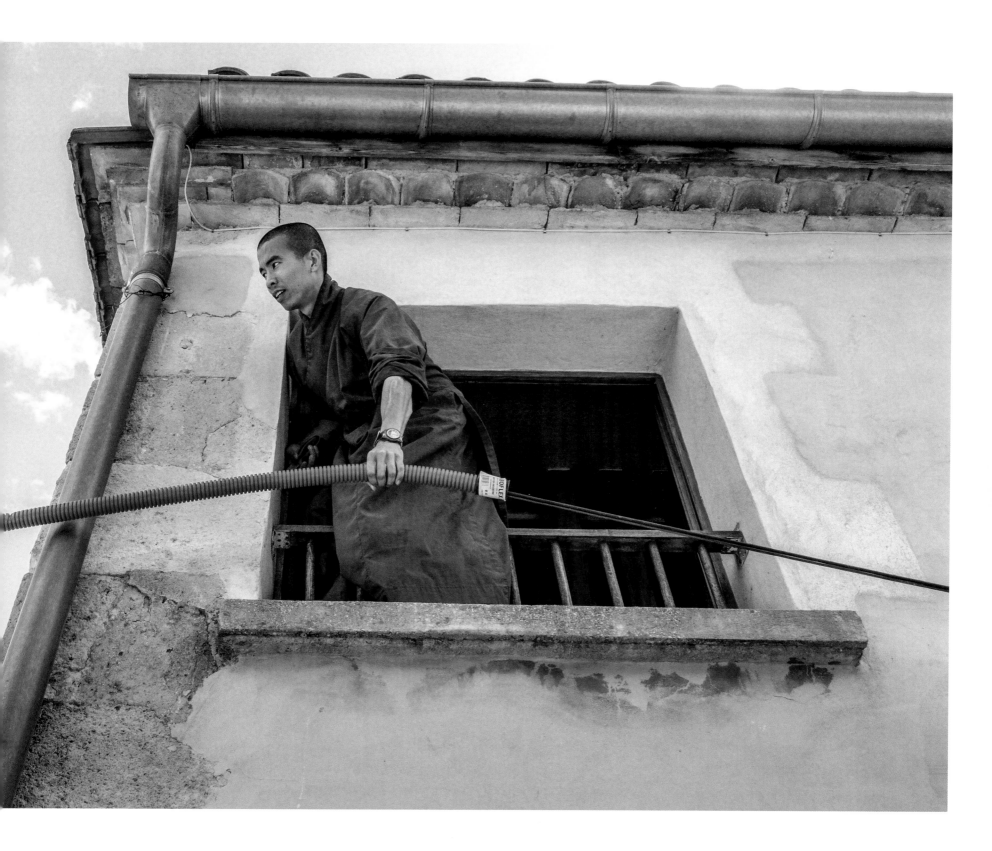

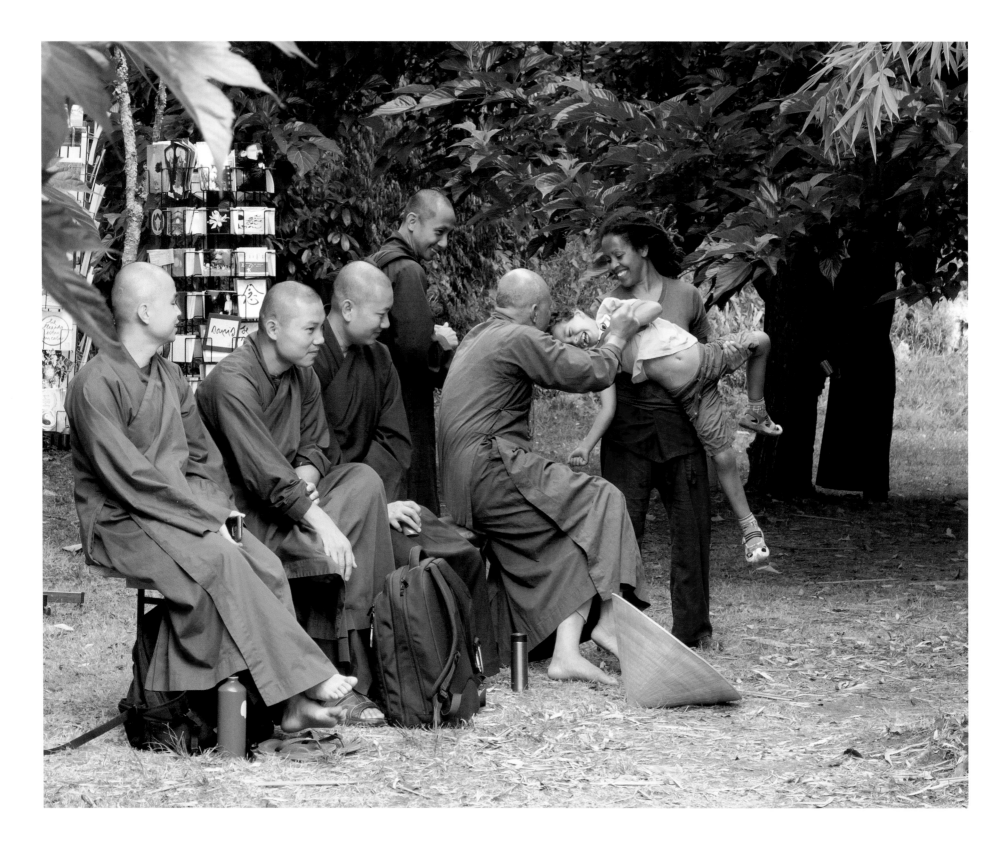

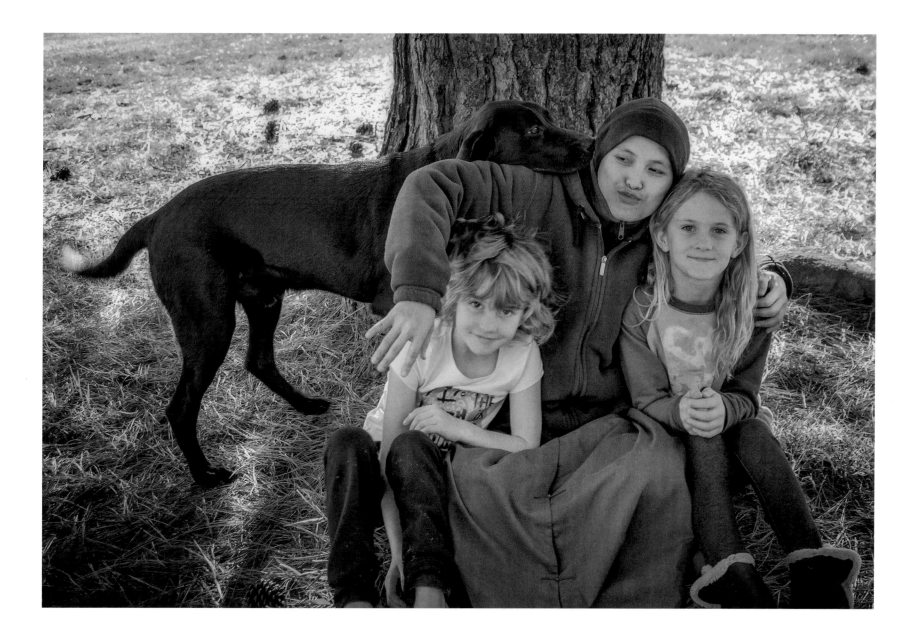

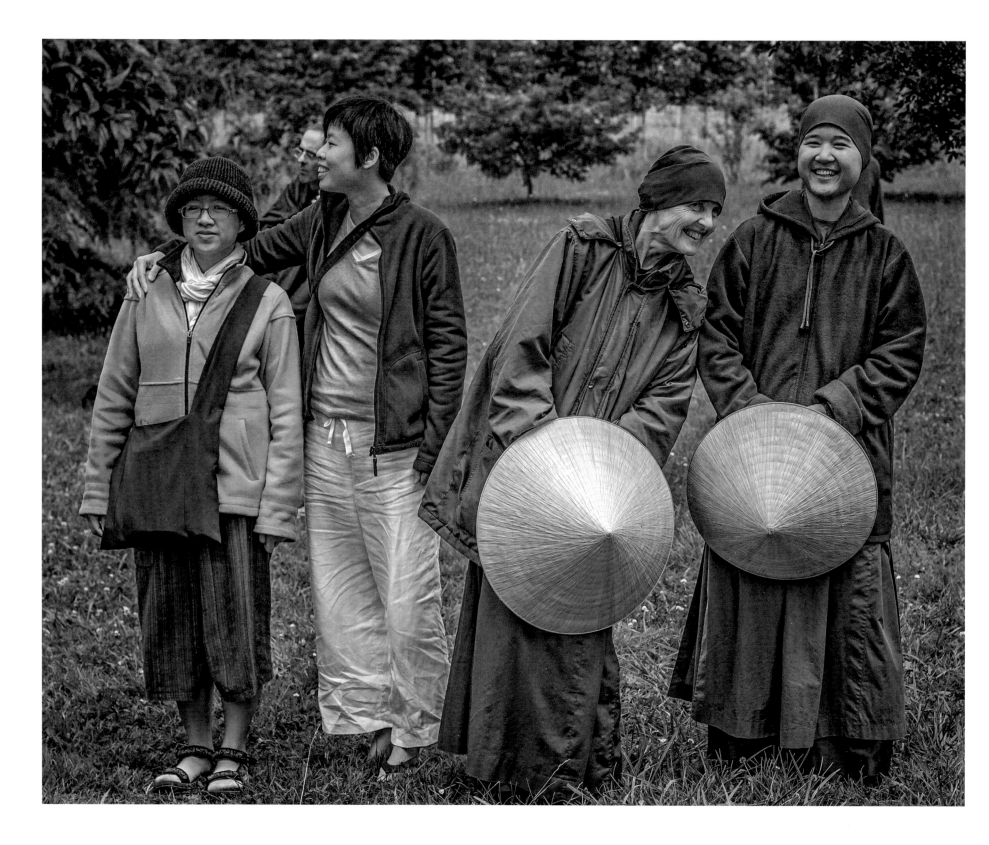

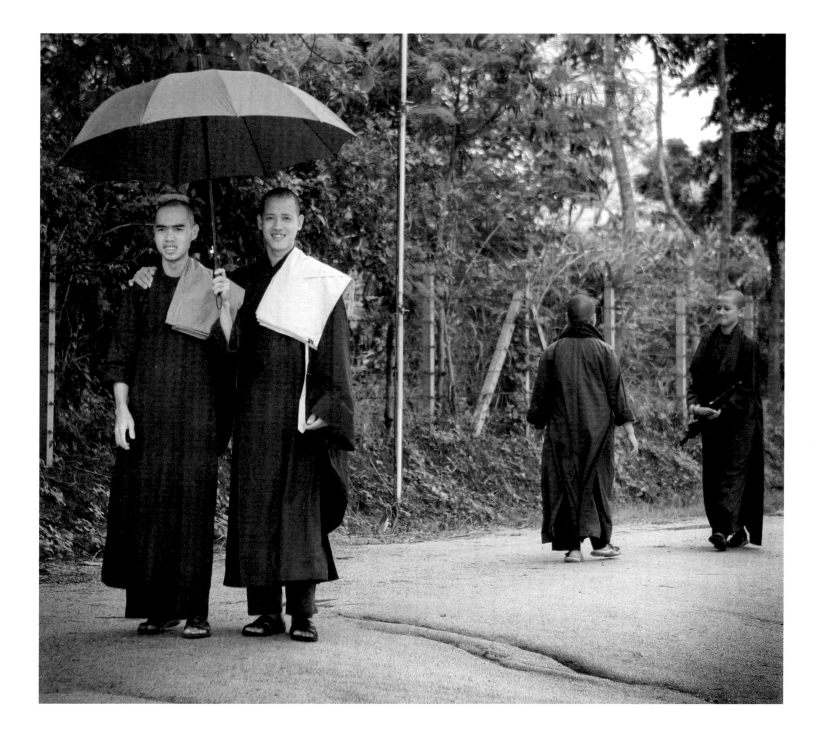

This body is not me.
I am not limited by this body.
I am life without boundaries.
I have never been born
and I have never died.

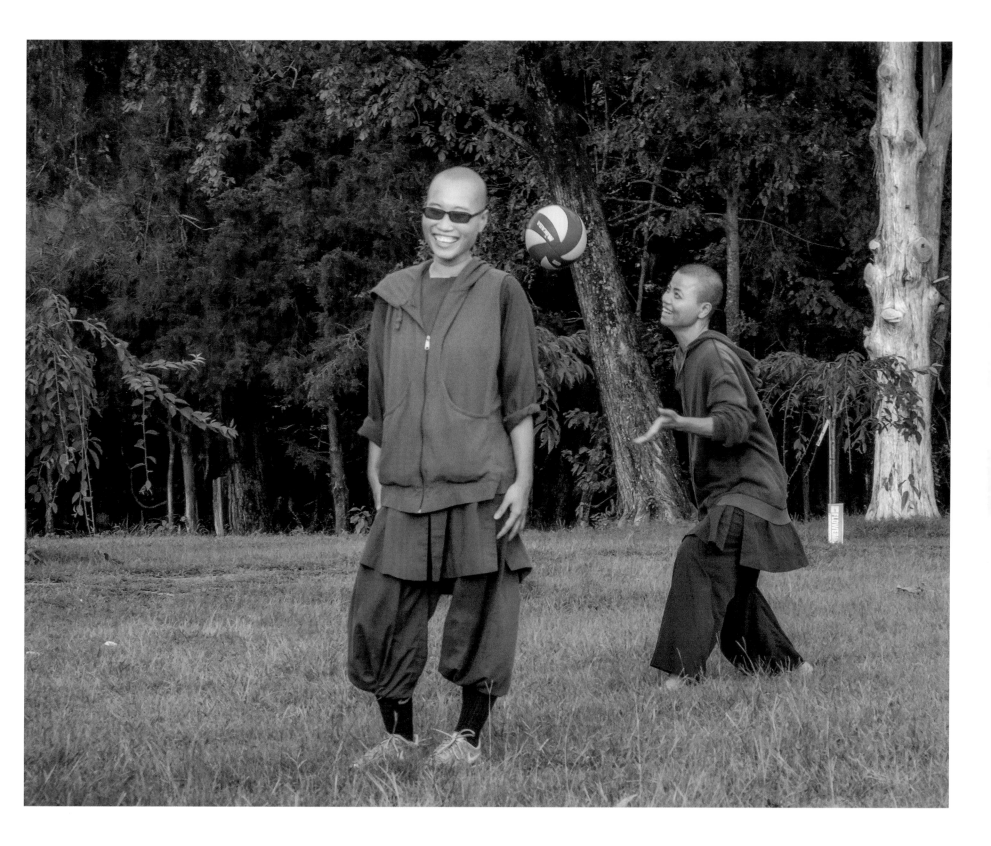

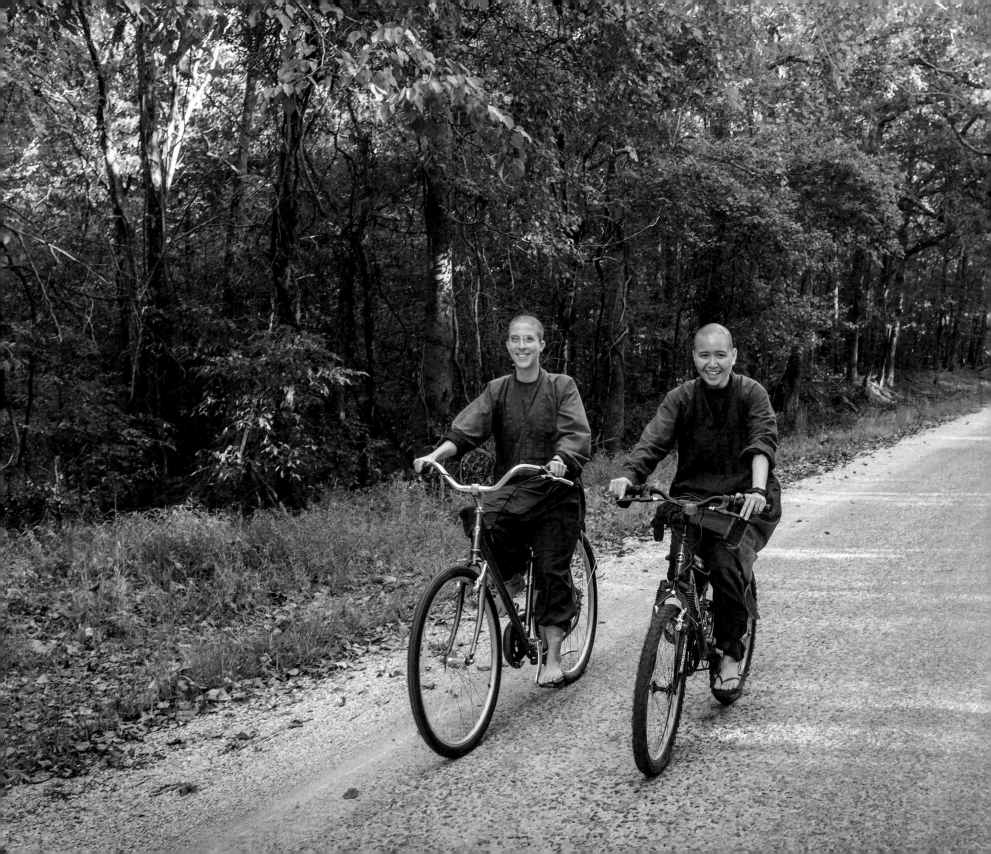

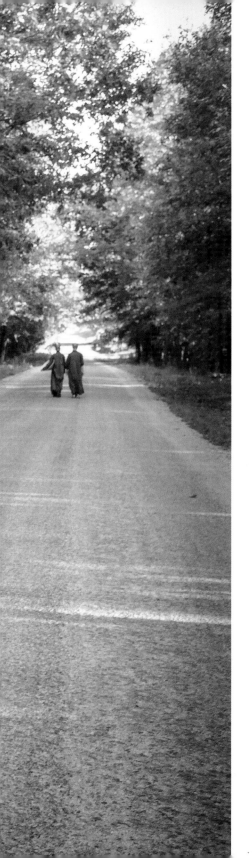

The mind can go in a thousand directions,
but on this beautiful path, I walk in peace.
With each step, the wind blows.
With each step, a flower blooms.

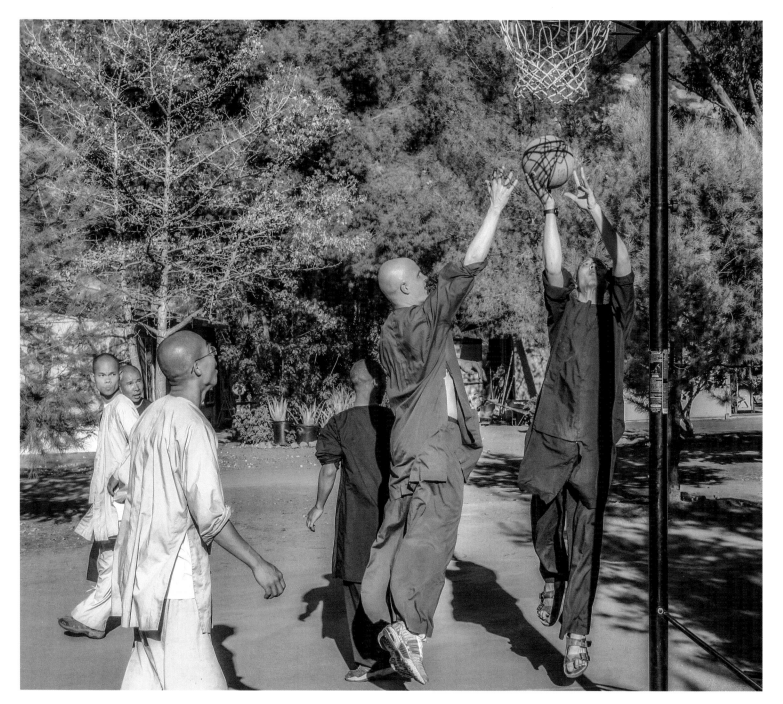
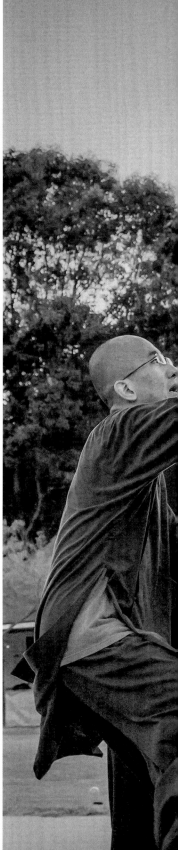

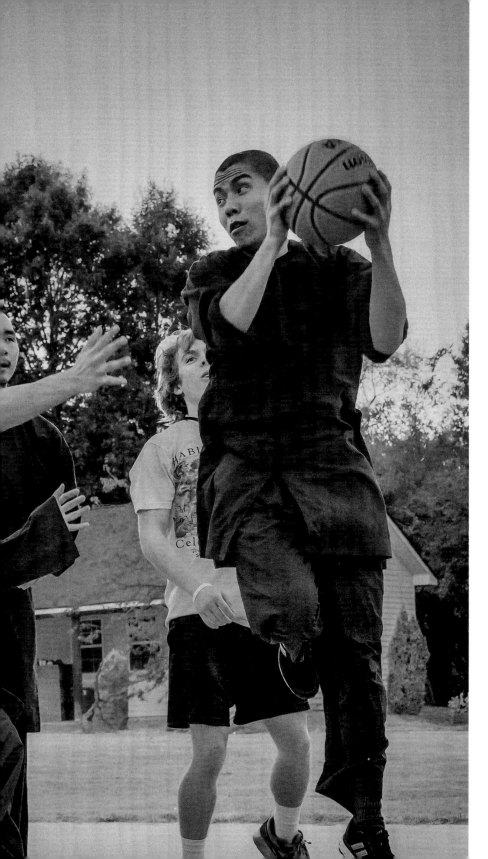
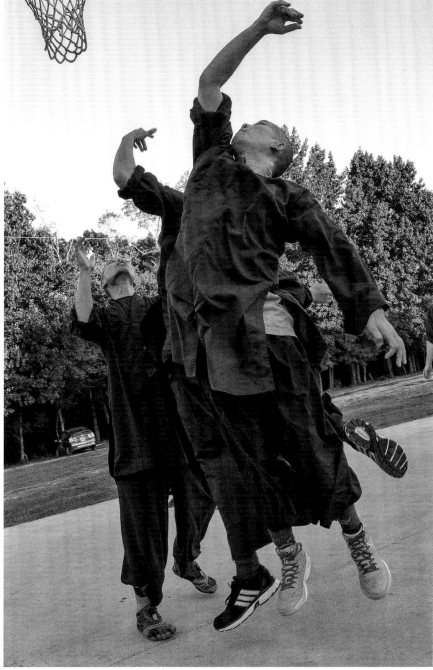

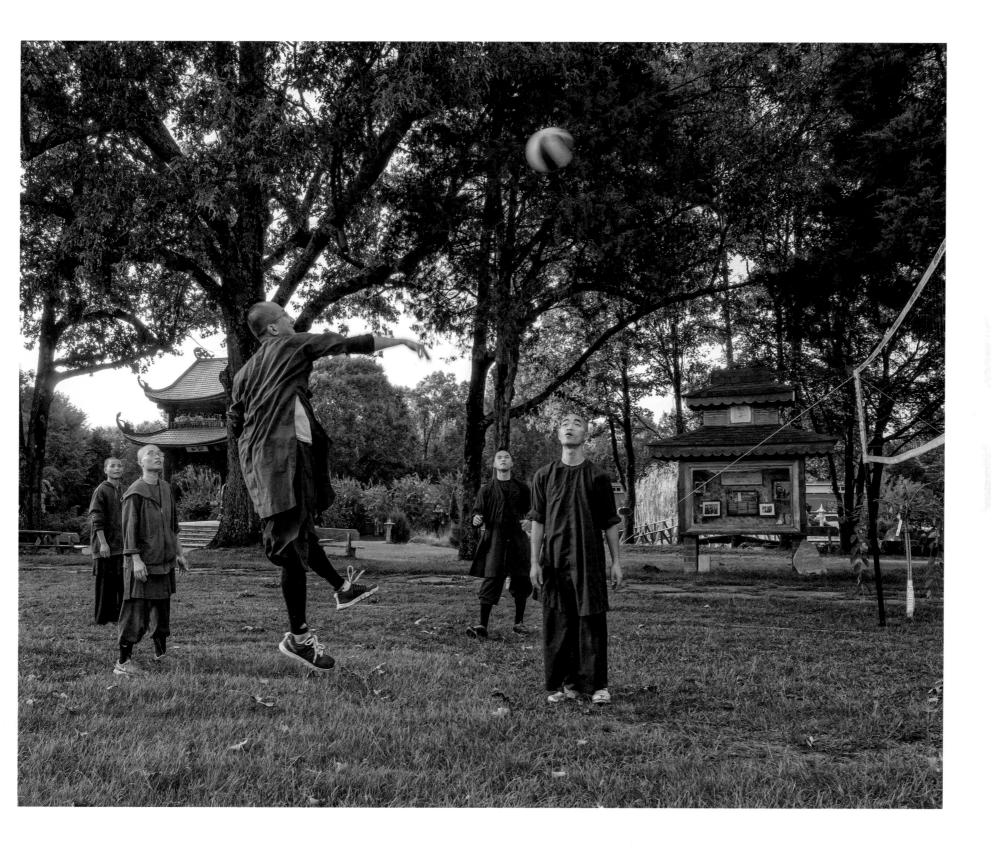

When you are a young person, you are like a young creek,

and you meet many rocks, many obstacles, and difficulties on your way.

You hurry to get past these obstacles and get to the ocean.

But as the creek moves down through the fields, it becomes larger and calmer,

and it can enjoy the reflection of the sky. It's wonderful.

You will arrive at the sea anyway, so enjoy the journey.

Enjoy the sunshine, the sunset, the moon, the birds, the trees,

and the many beauties along the way. Taste every moment of your daily life.

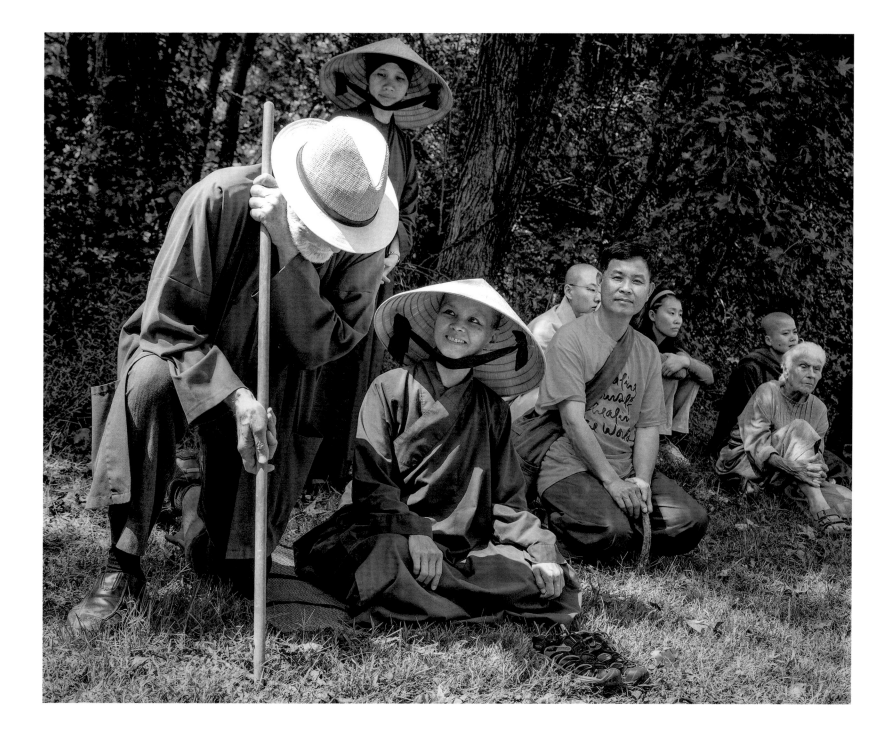

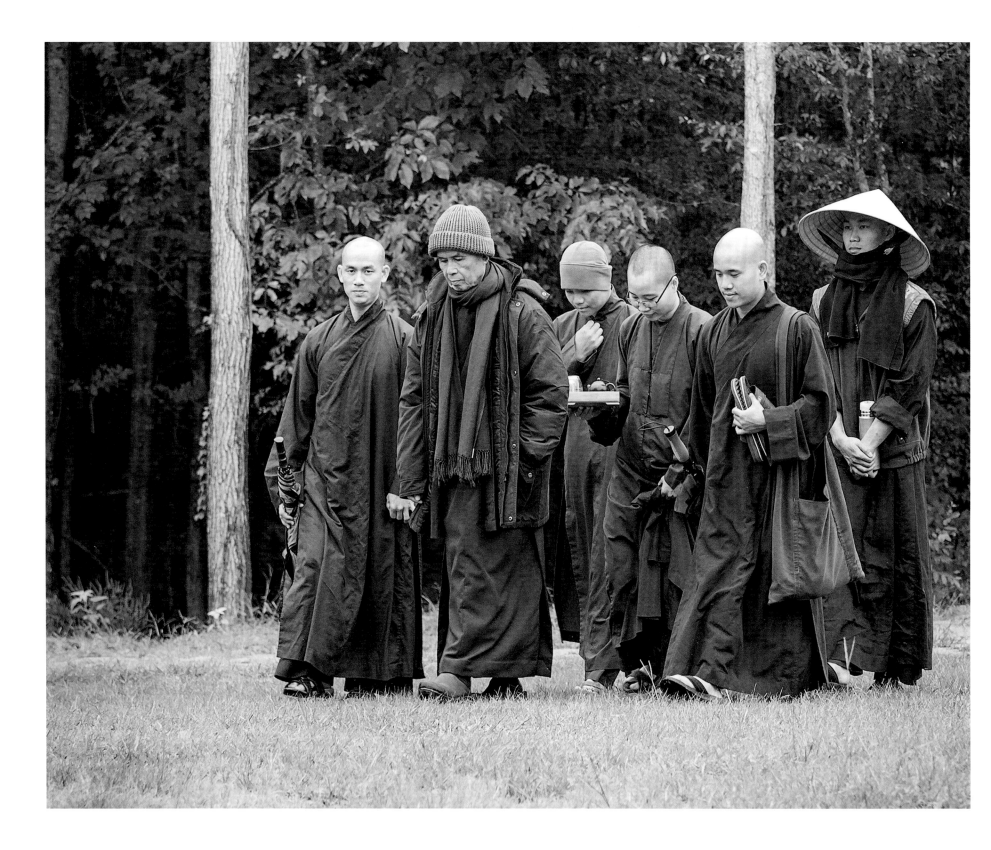

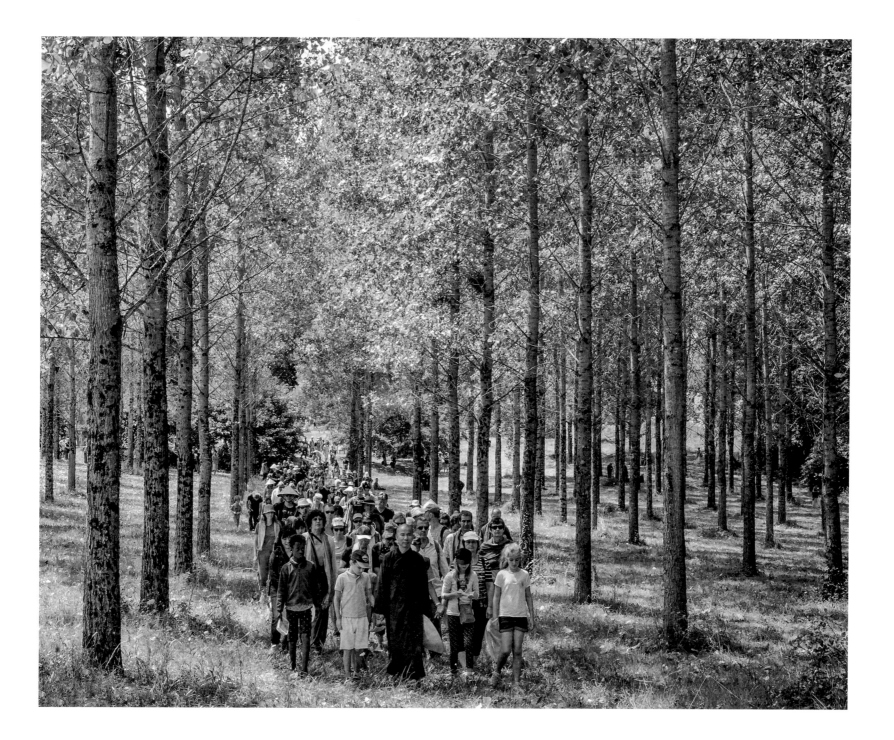

Feelings come and go
like clouds in a windy sky.
Conscious breathing
is my anchor.

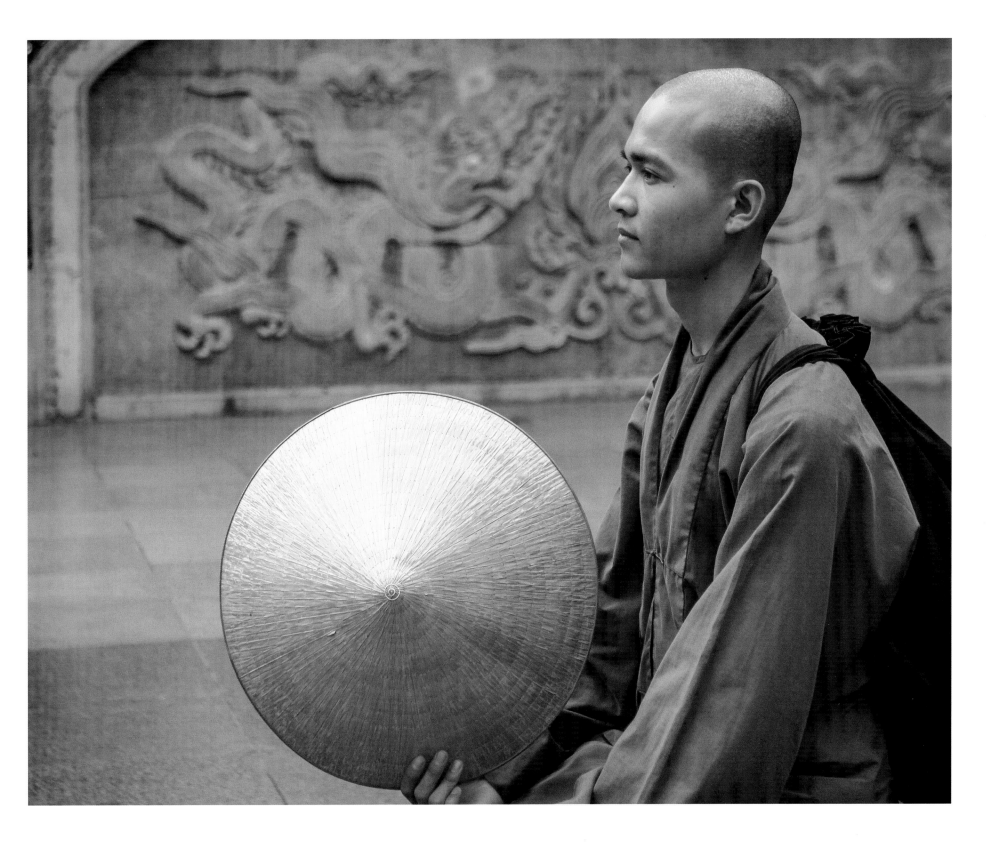

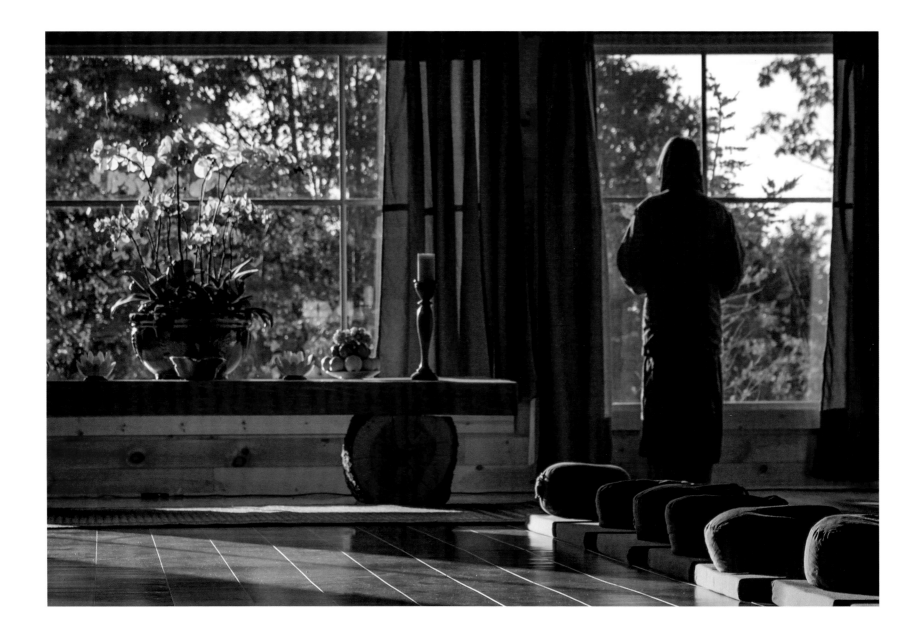

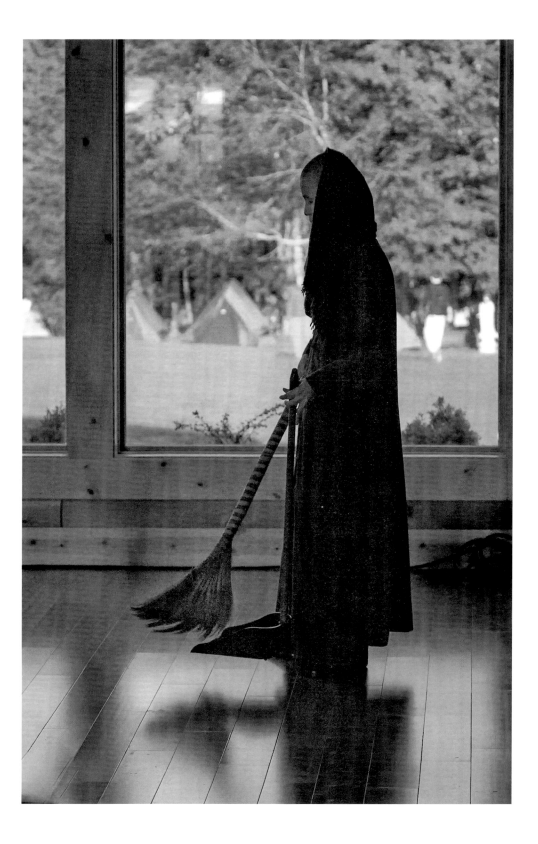

Many of us consider growing as a kind of increasing, and aging as a kind of decreasing. When we say that humans go from ashes to ashes and from dust to dust, it doesn't sound very joyful, because none of us wants to return to dust. But we don't know what dust really is. We value humans more than dust. The reality is that dust is something very wonderful. Every atom of matter is a vast mystery. *Be humble; you are made of dust. Be noble; you are made of stars.*

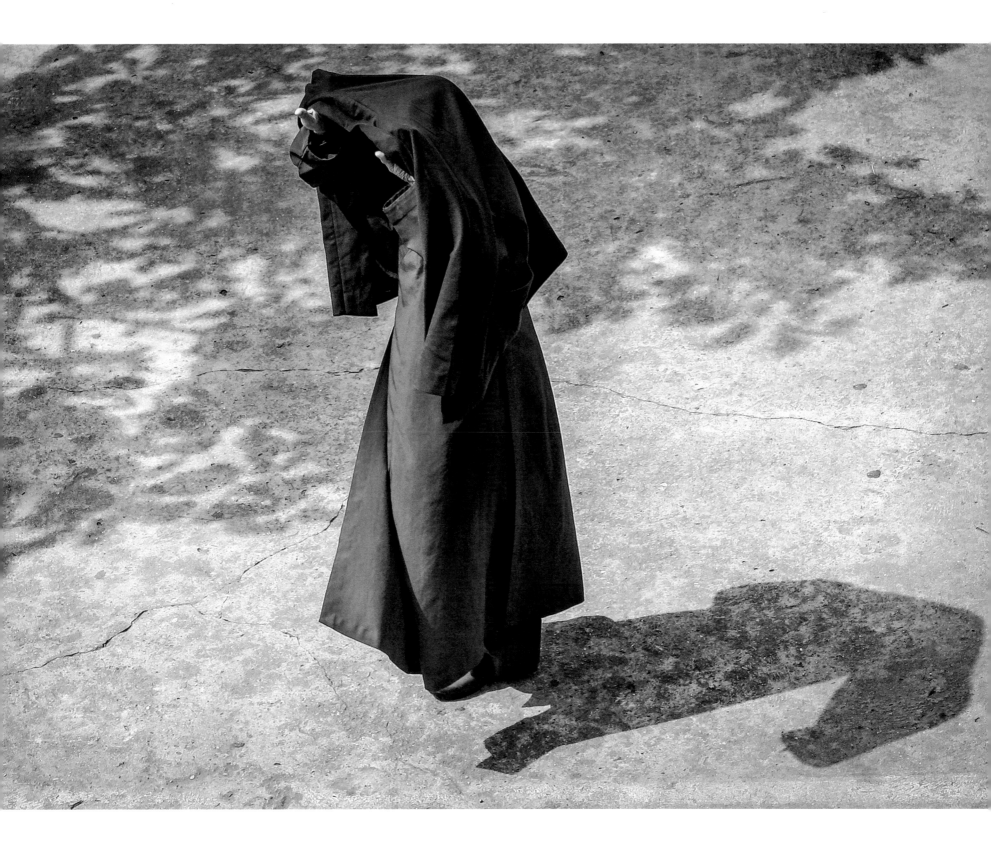

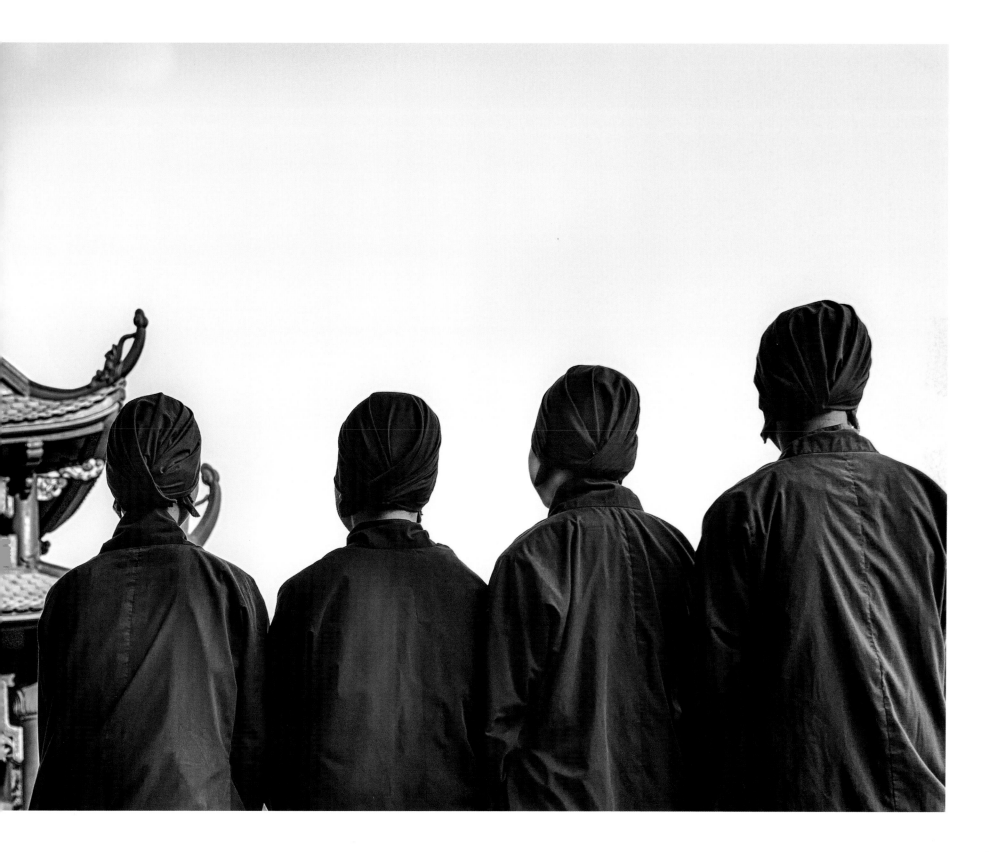

Body, speech, and mind in perfect oneness,
I send my heart along with the sound of this bell.
May all the hearers awaken from forgetfulness
and transcend the path of anxiety and sorrow.

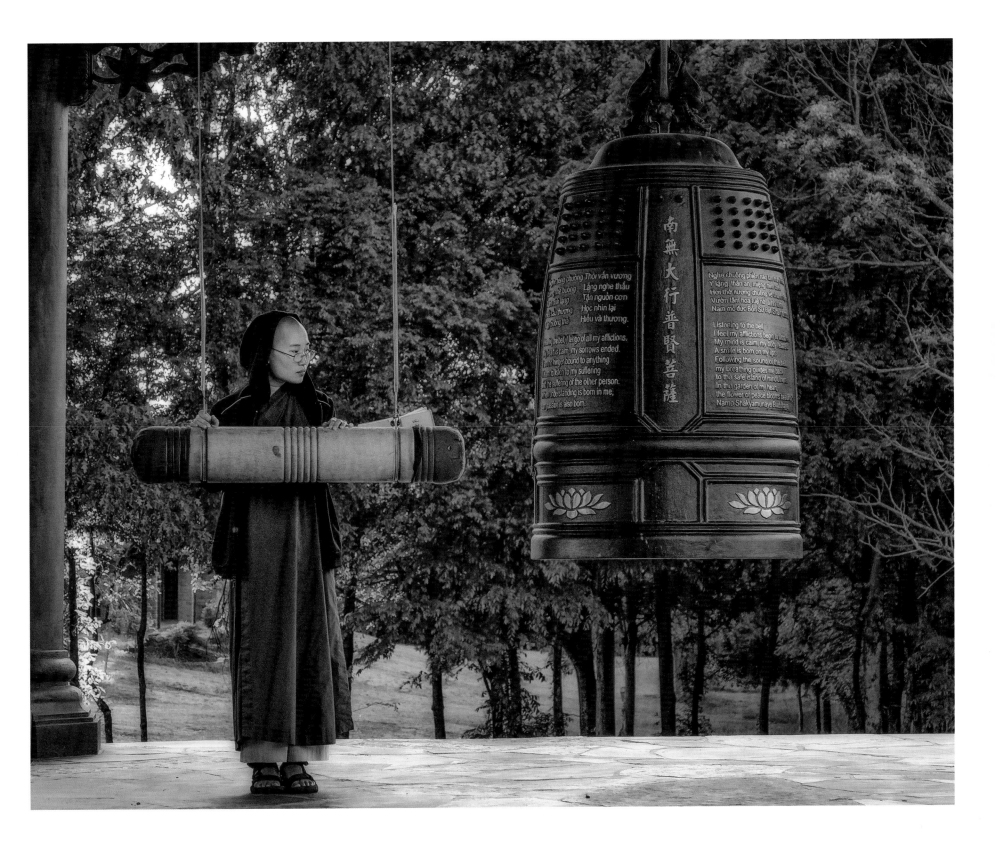

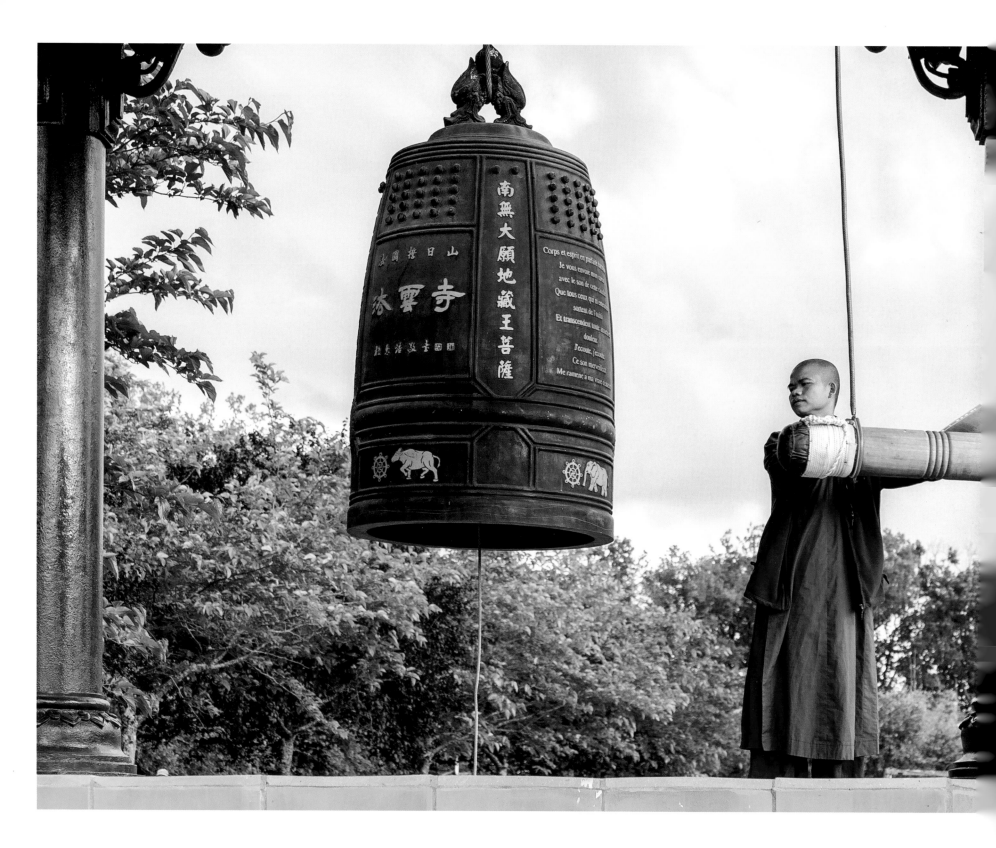

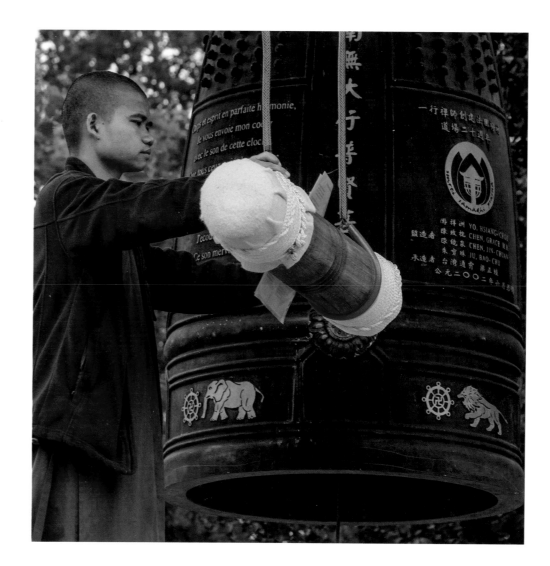

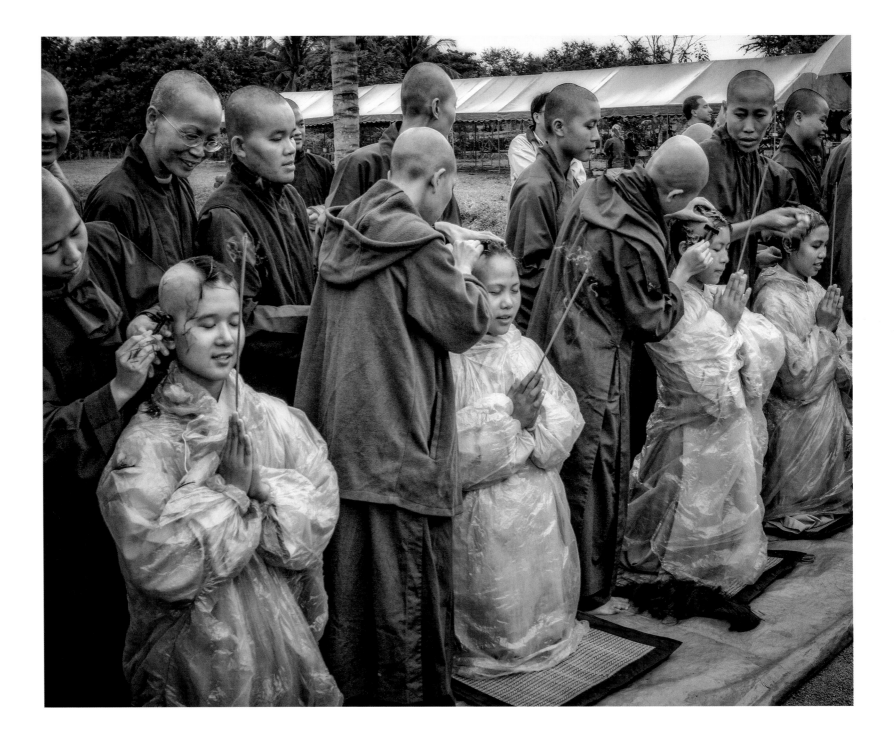

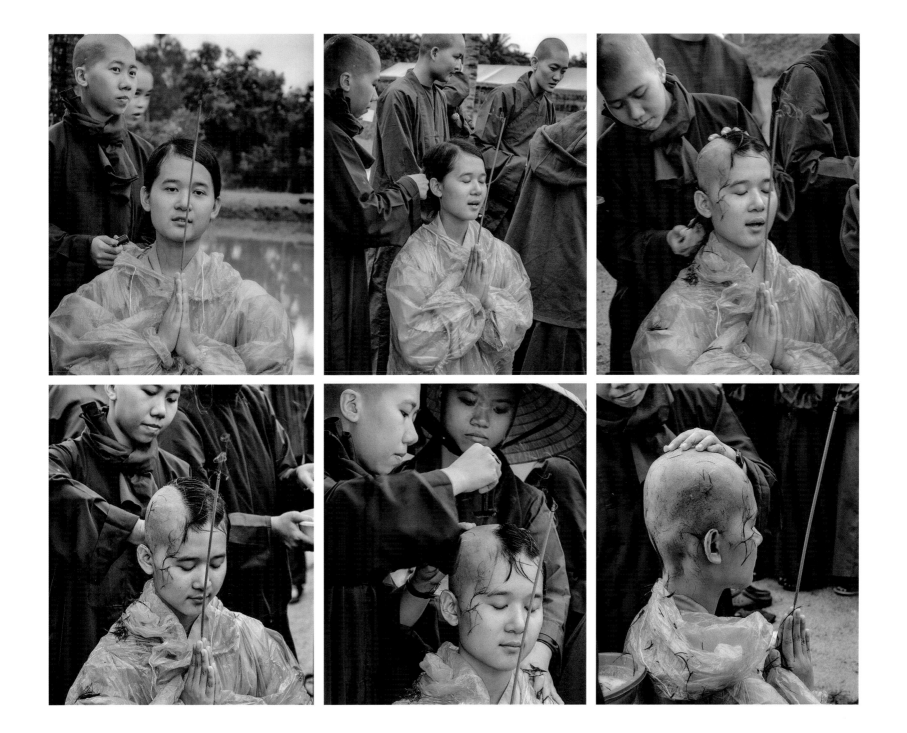

Kiss the Earth with your feet.
Bring the Earth your love and happiness.
The Earth will be safe
when we feel safe in ourselves.

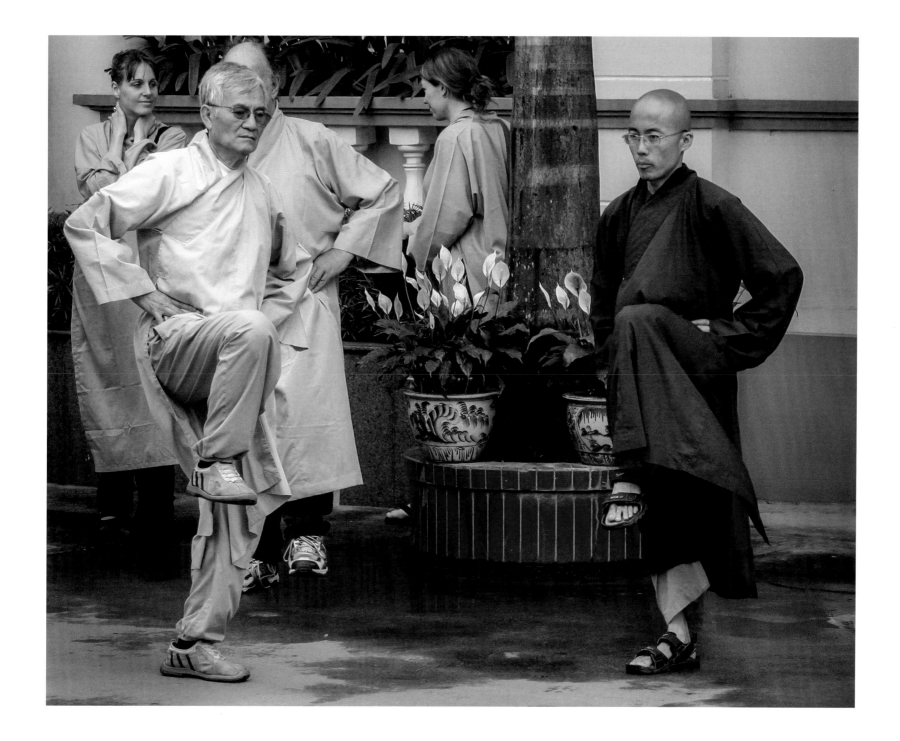

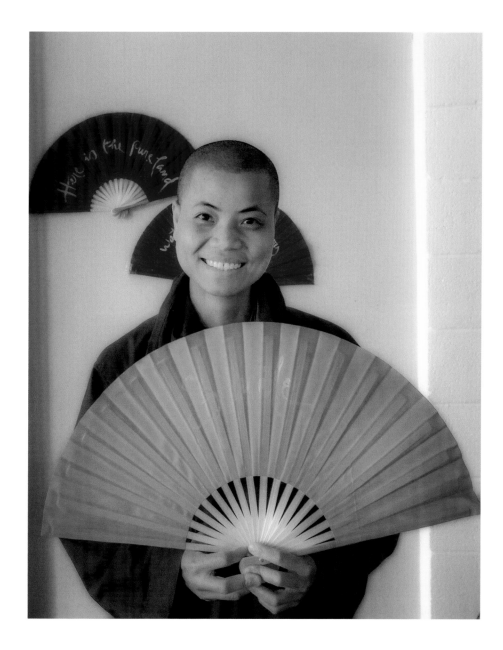

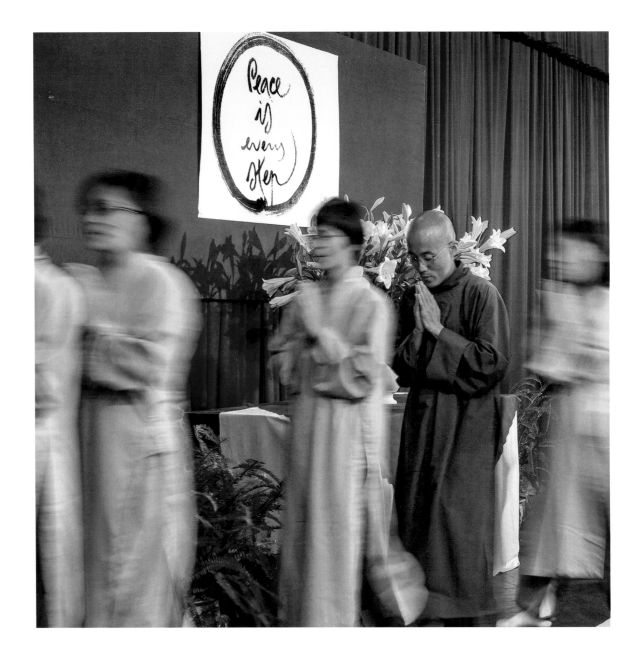

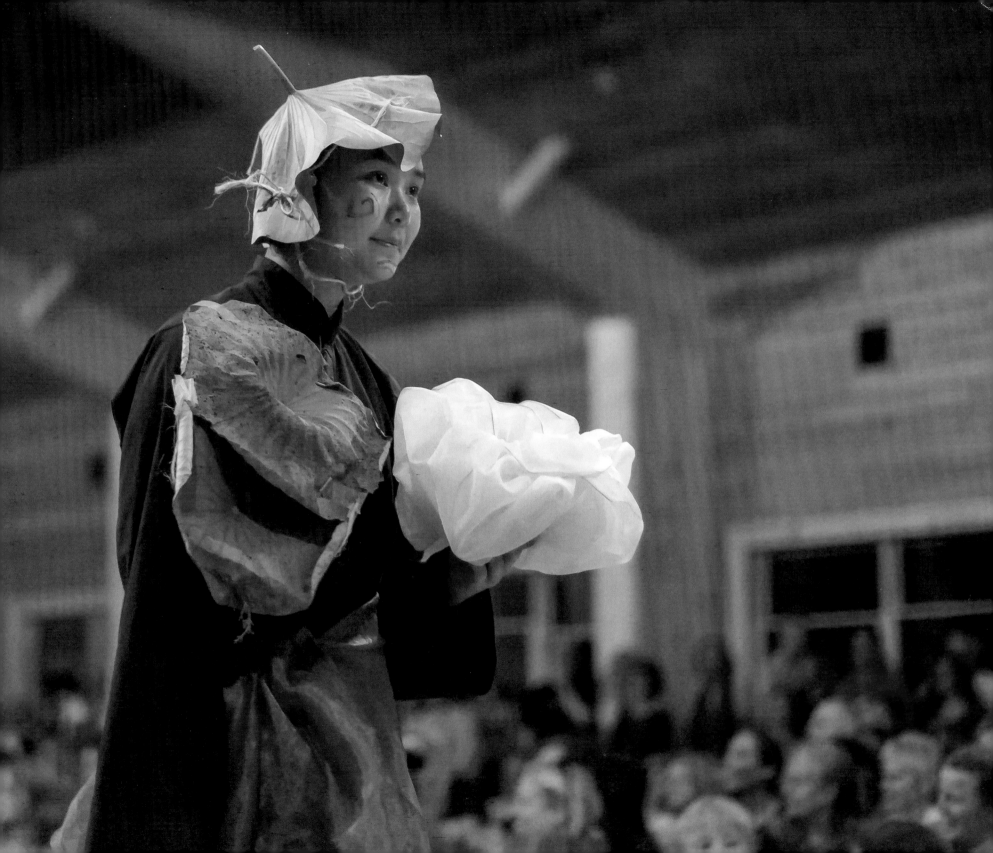

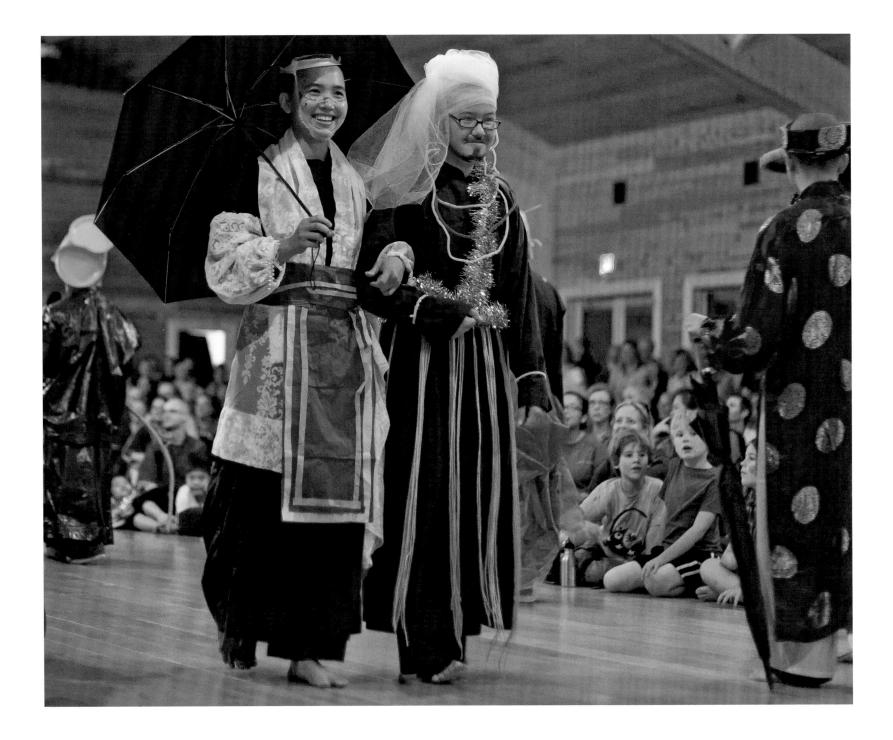

I promise myself that I will enjoy every minute of the day that is given me to live.

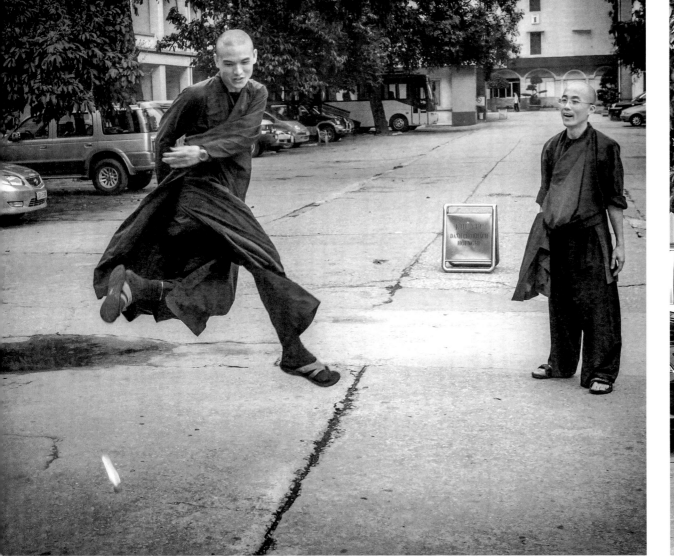

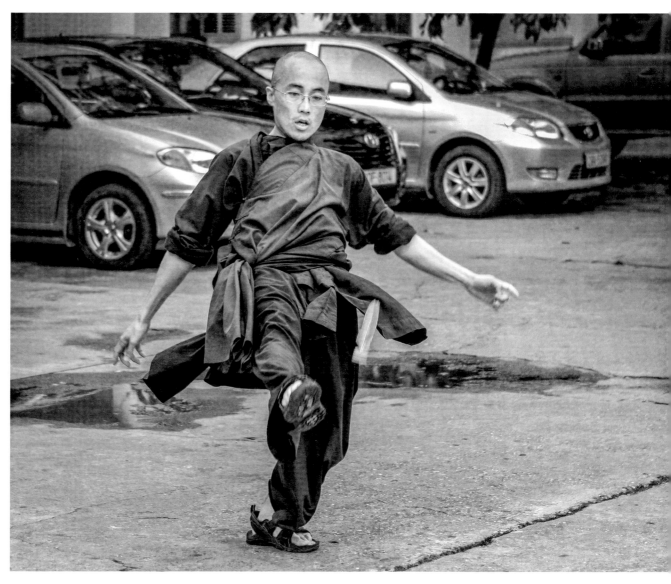

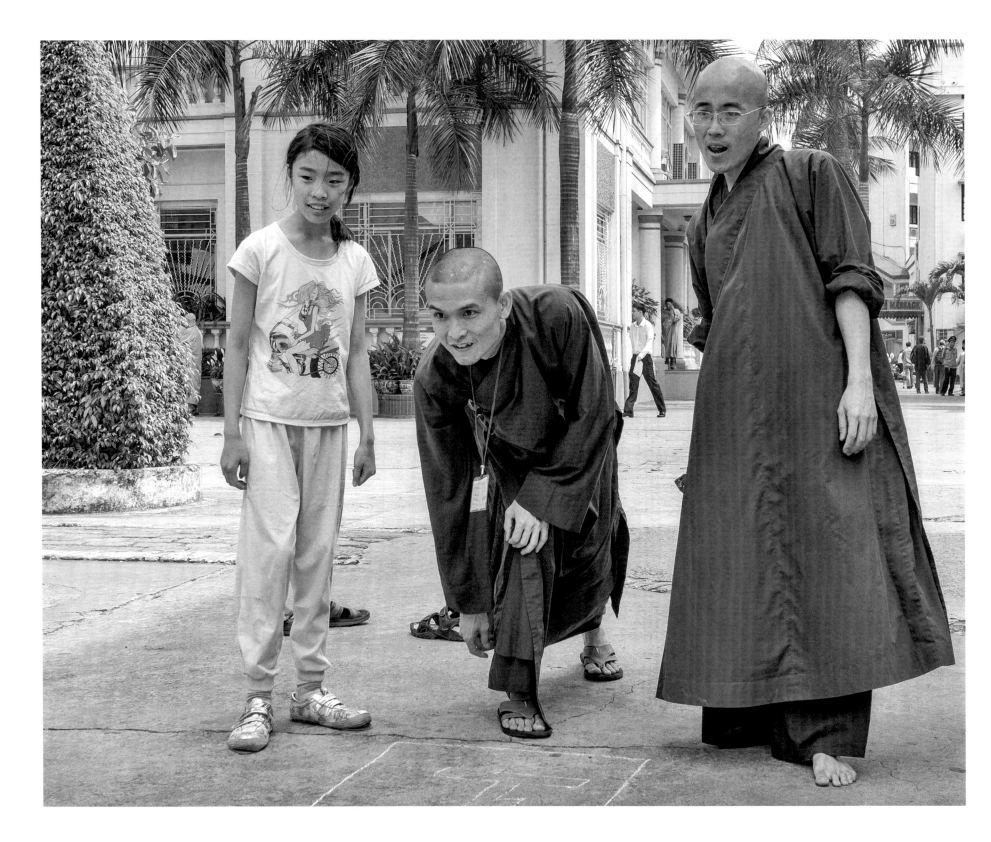

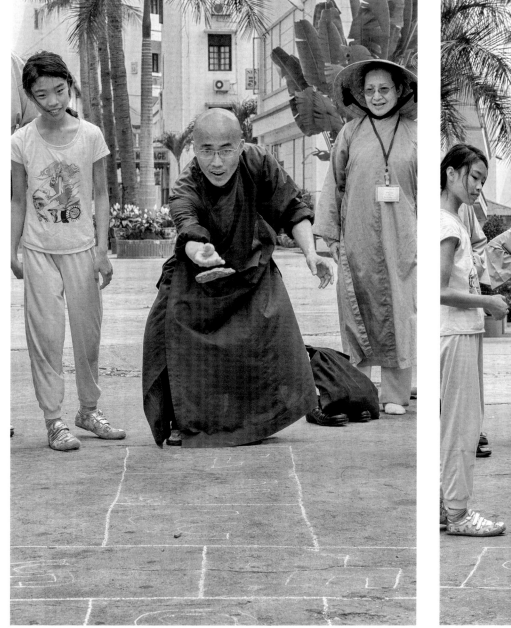
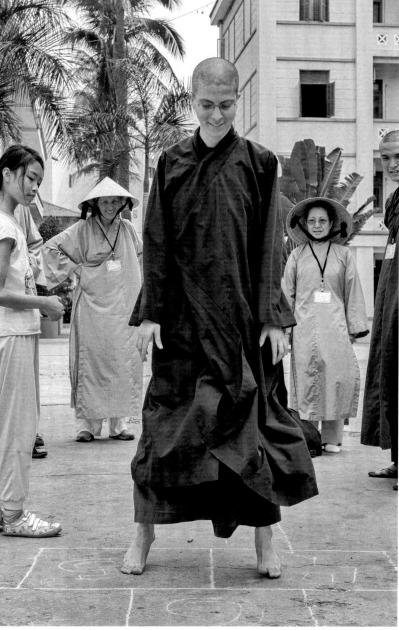

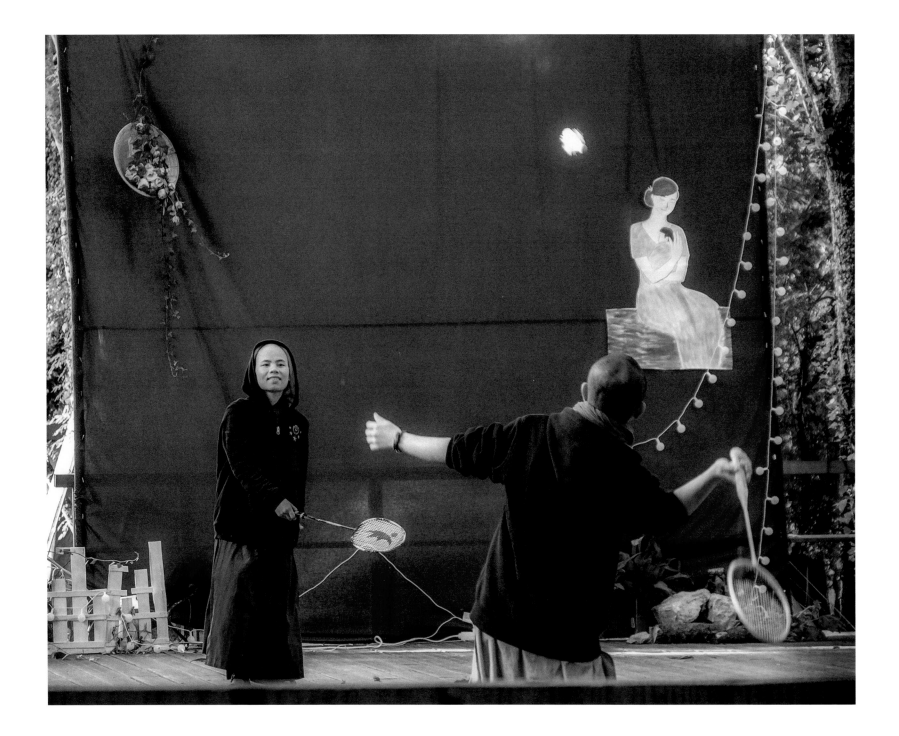

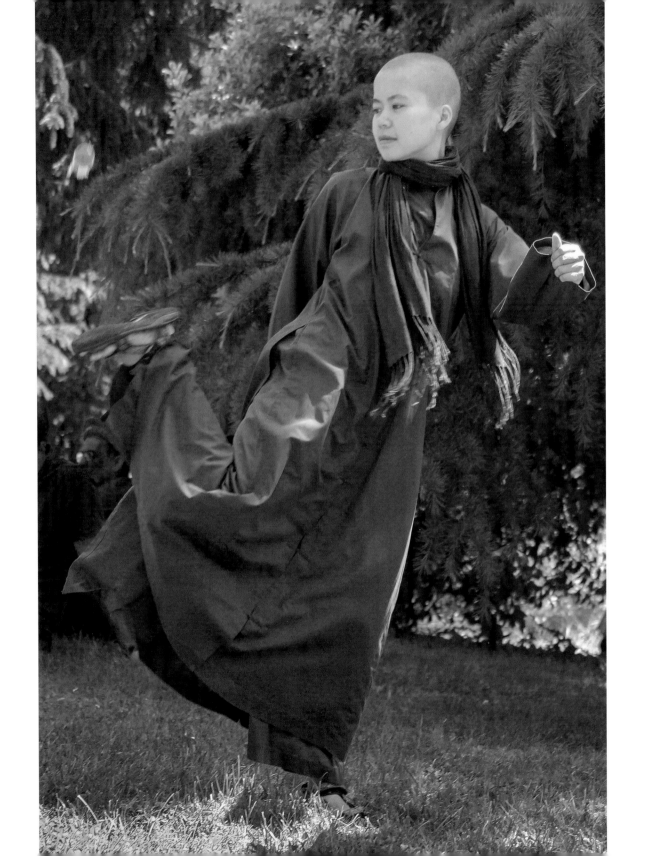

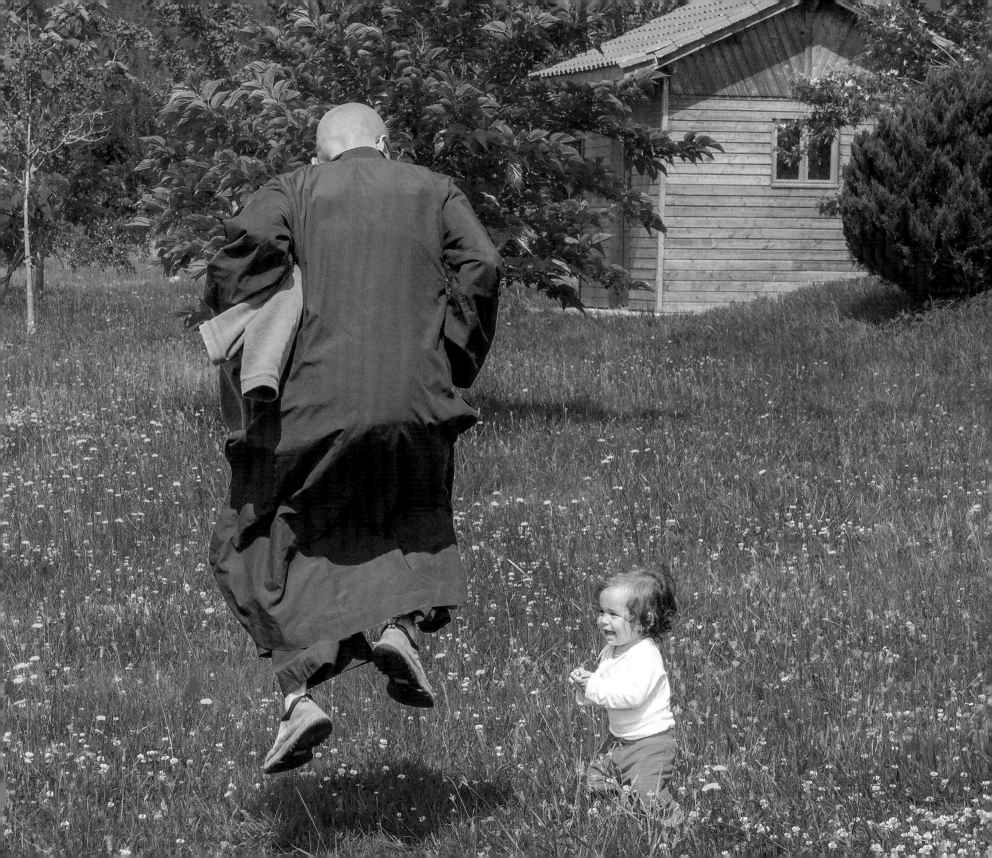

The most precious gift we can offer others
is our presence.
When mindfulness embraces those we love,
they will bloom like flowers.

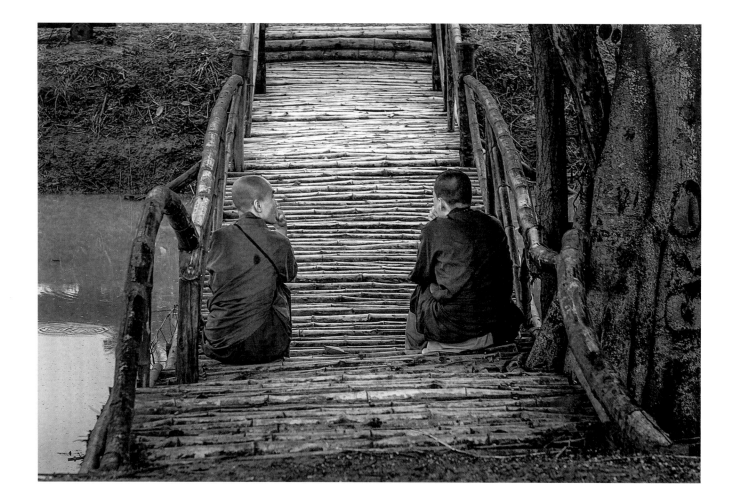

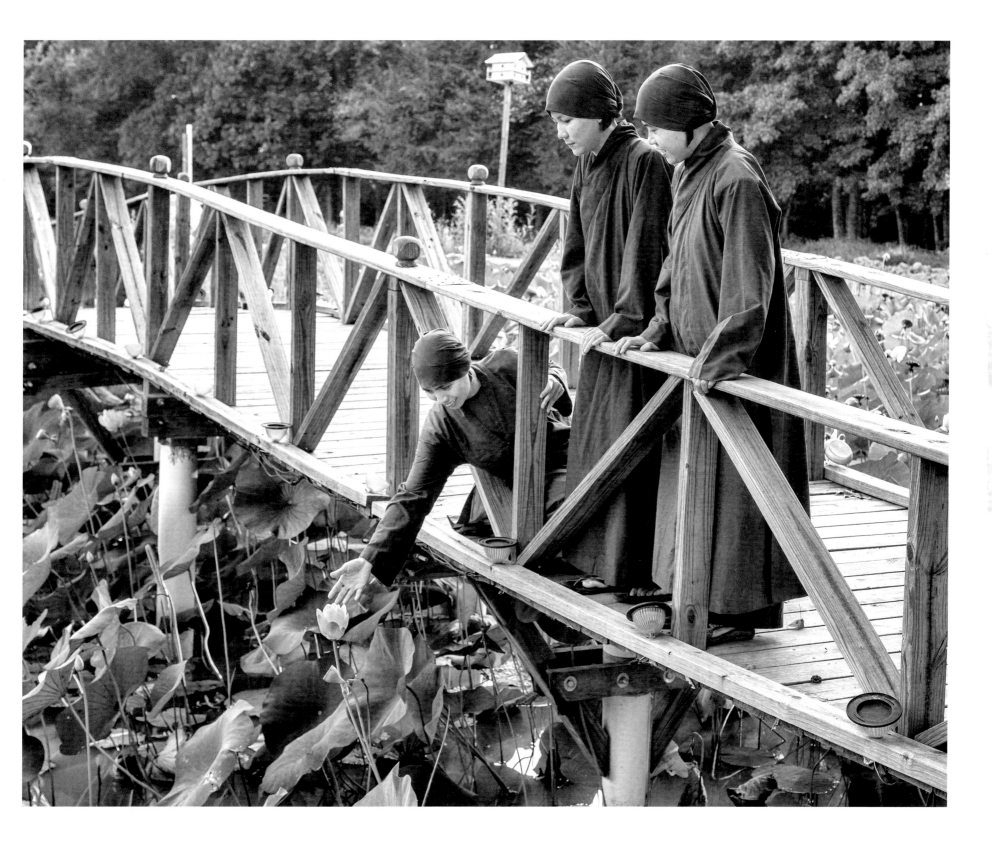

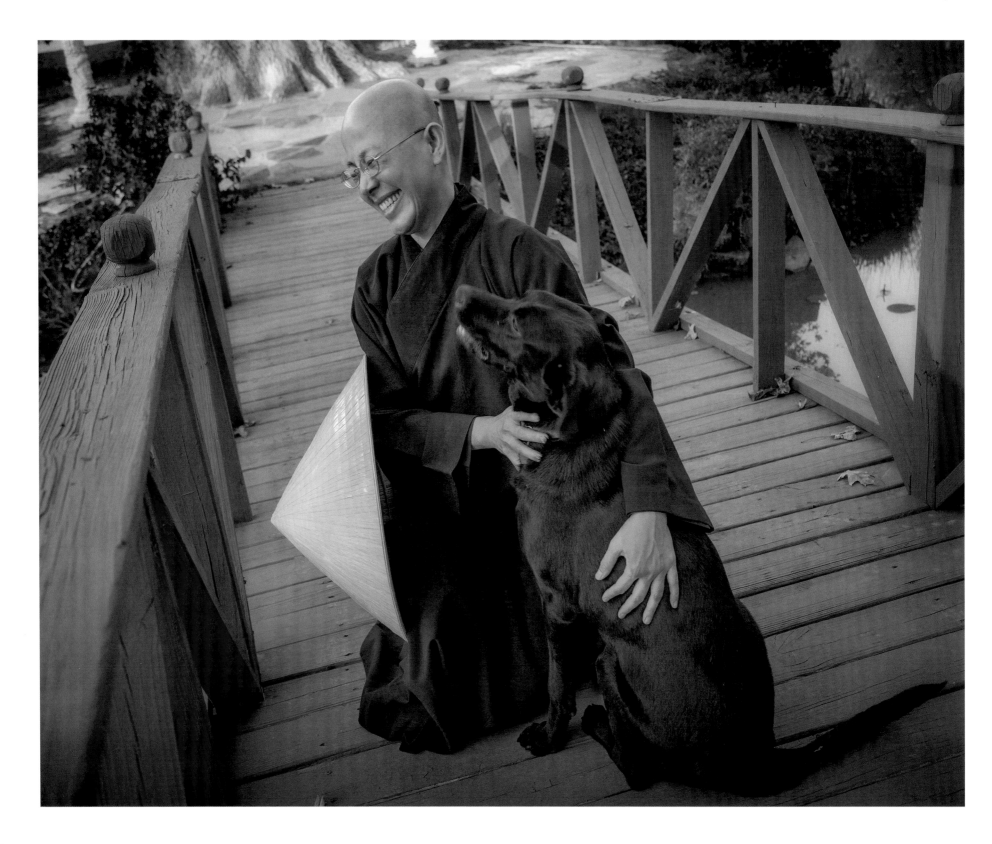

Compassion is a beautiful flower
born of understanding.

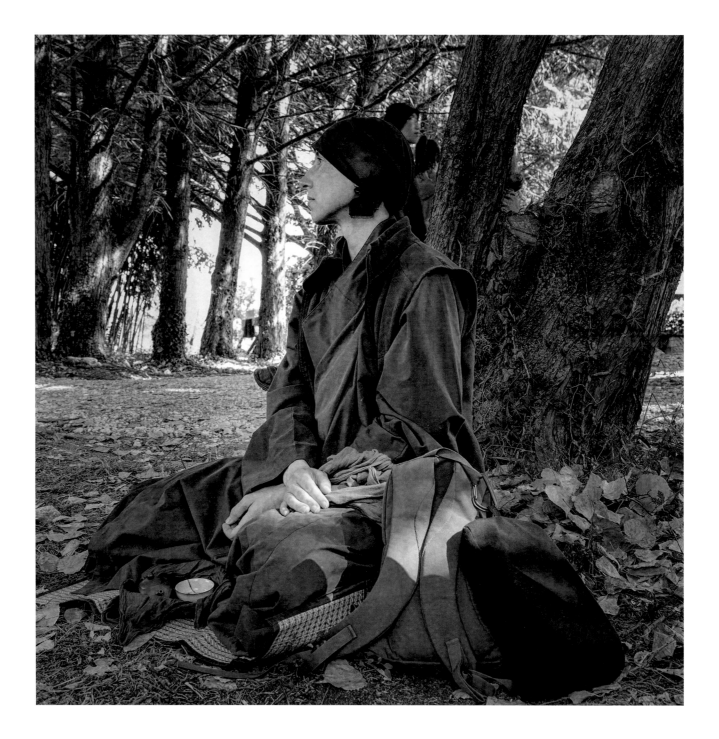

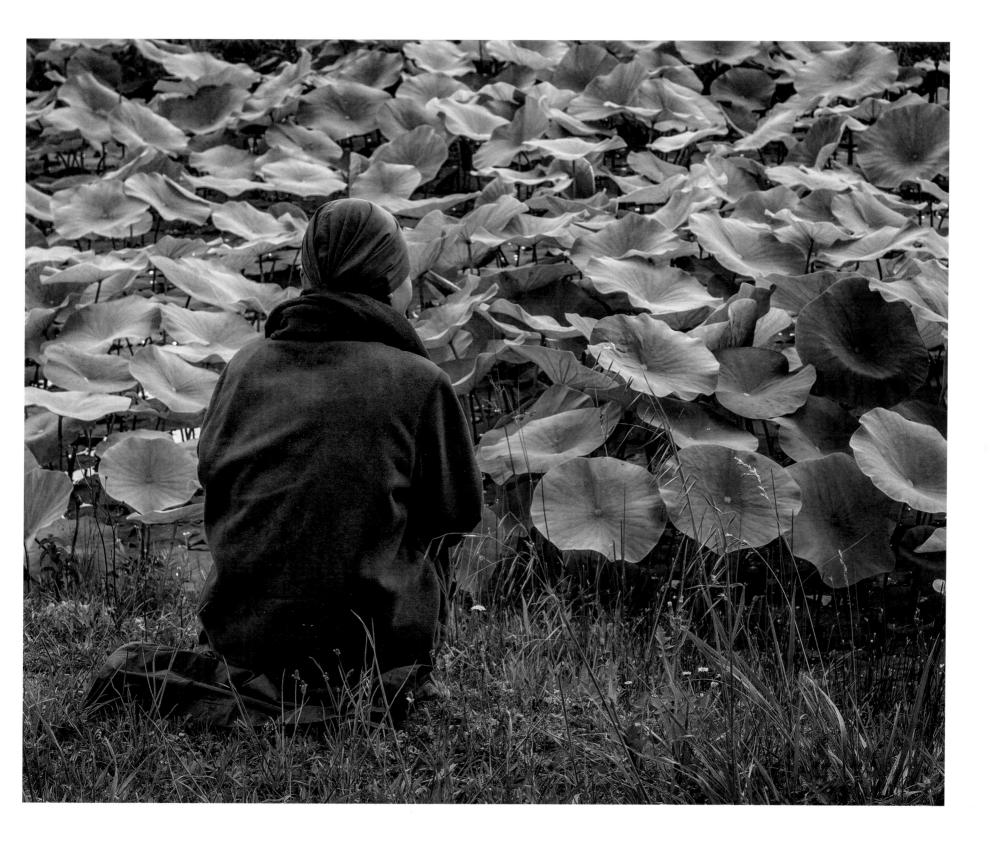

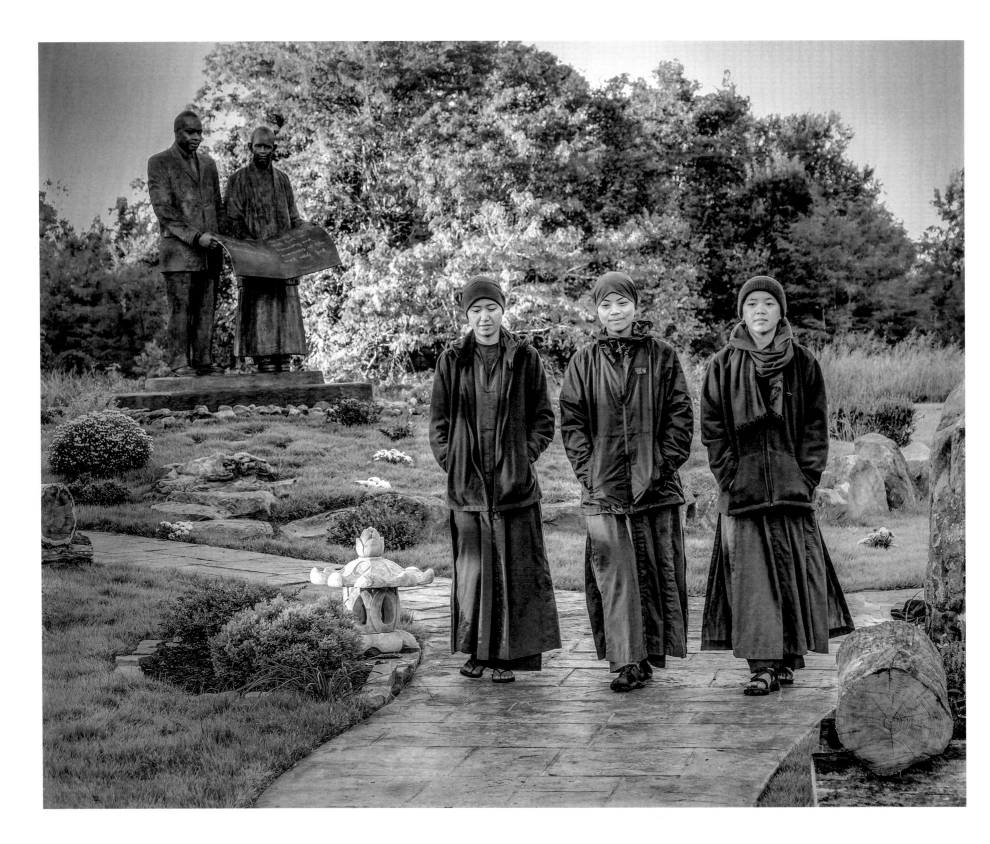

We are aware that all generations of our ancestors
and all future generations are alive in us.

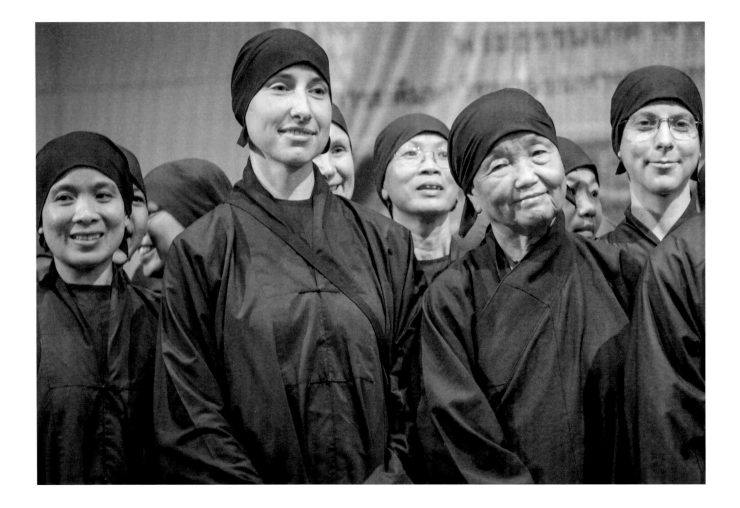

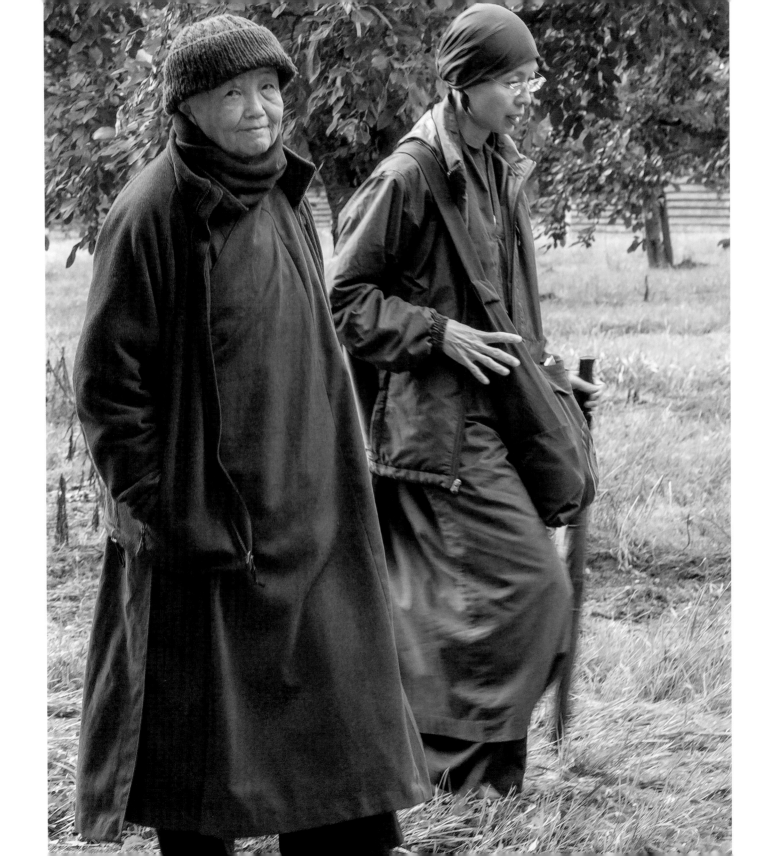

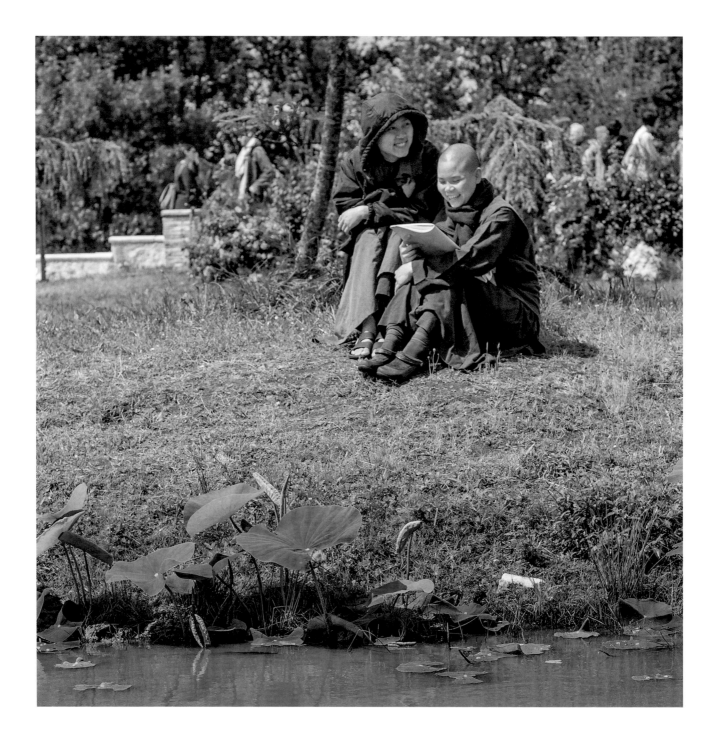

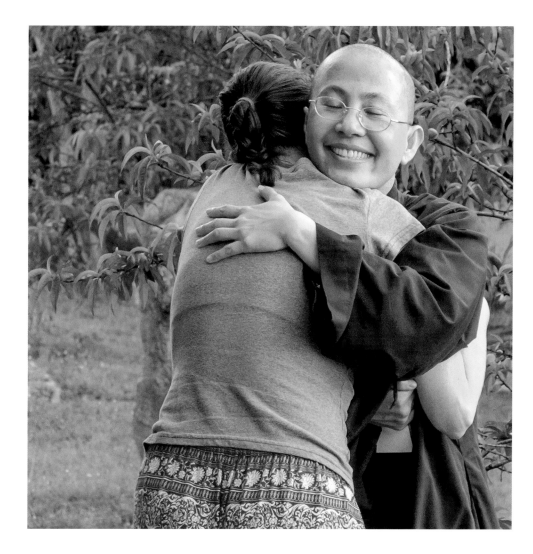

I am in love with Mother Earth.

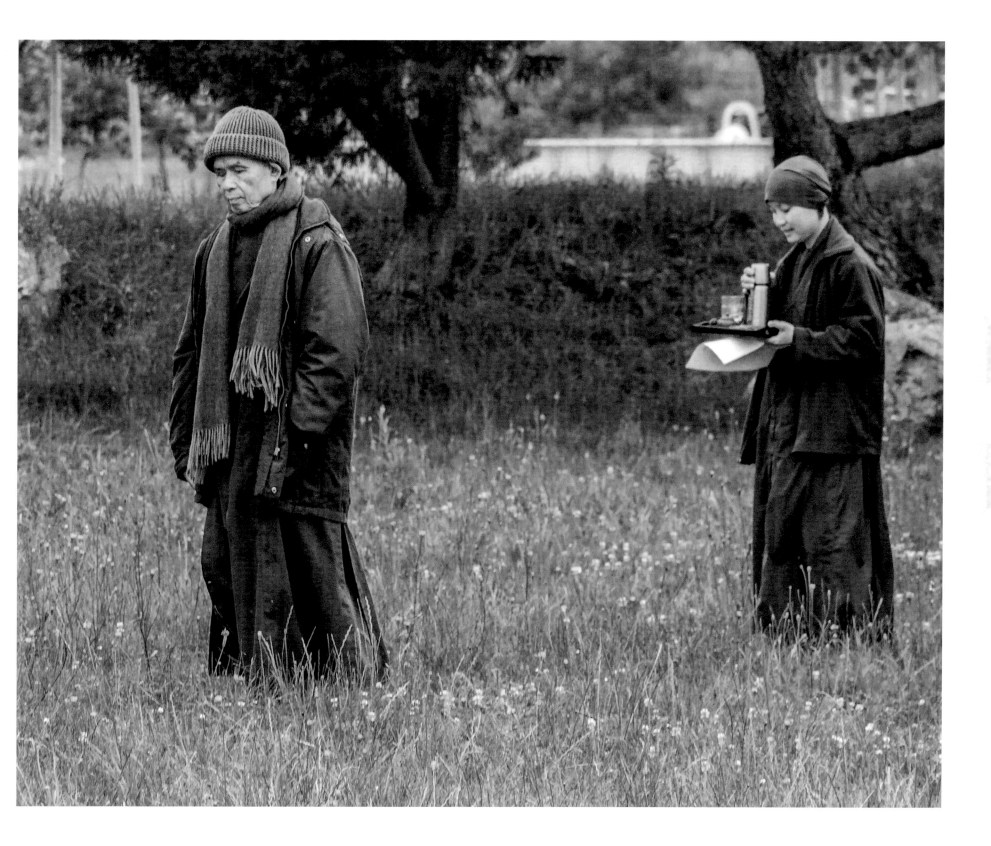

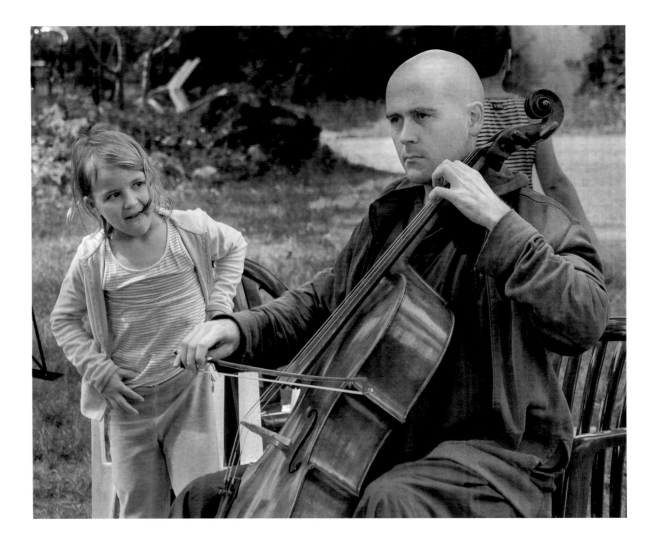

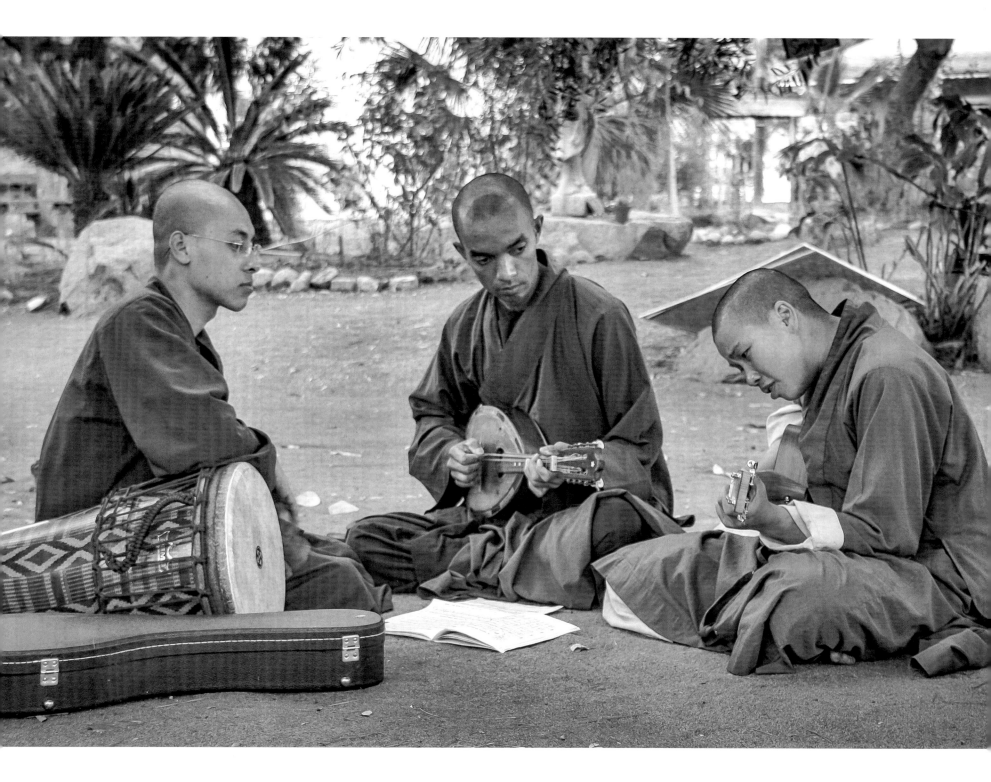

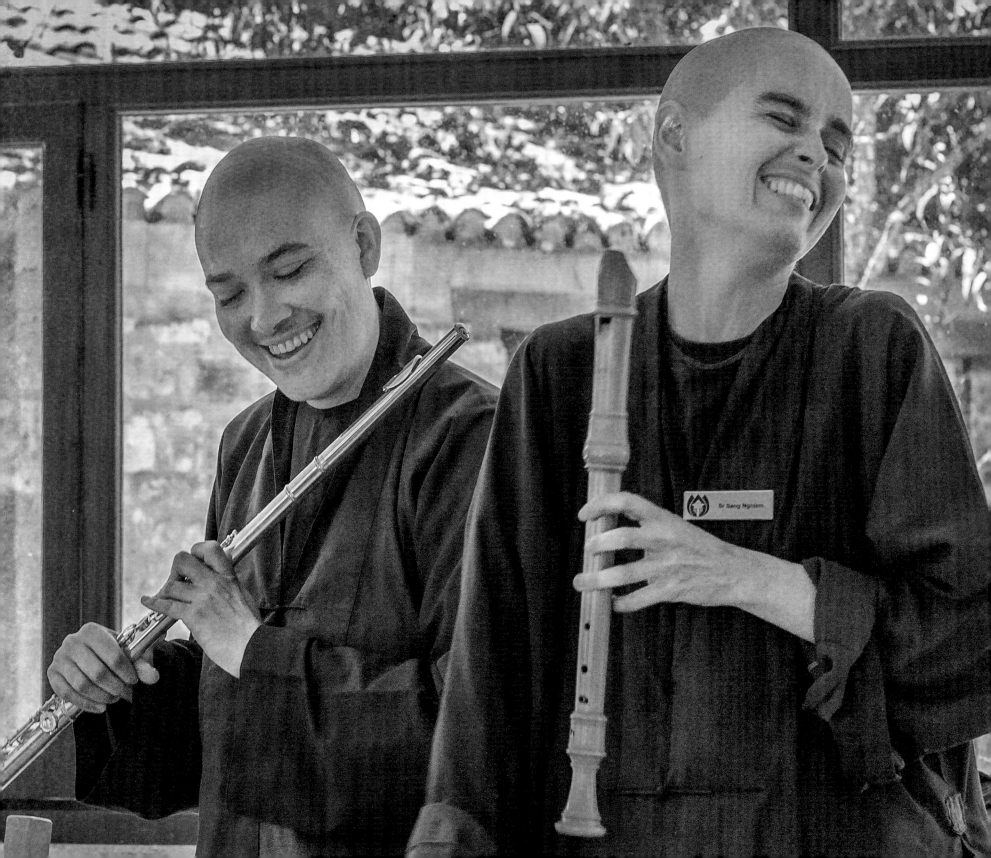

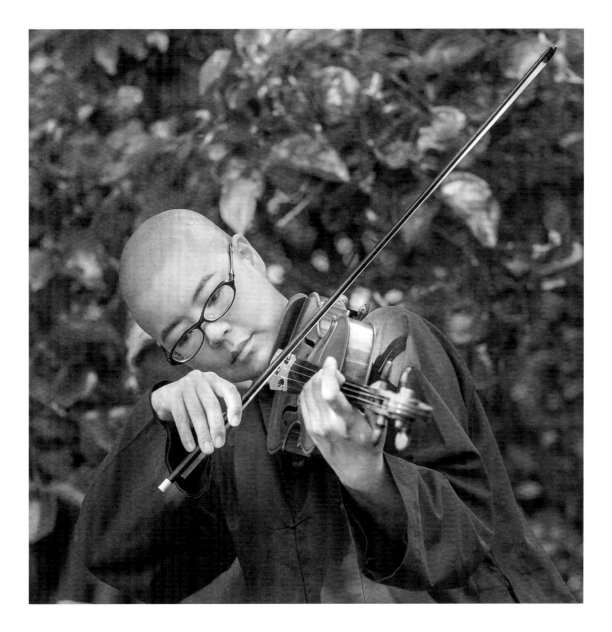

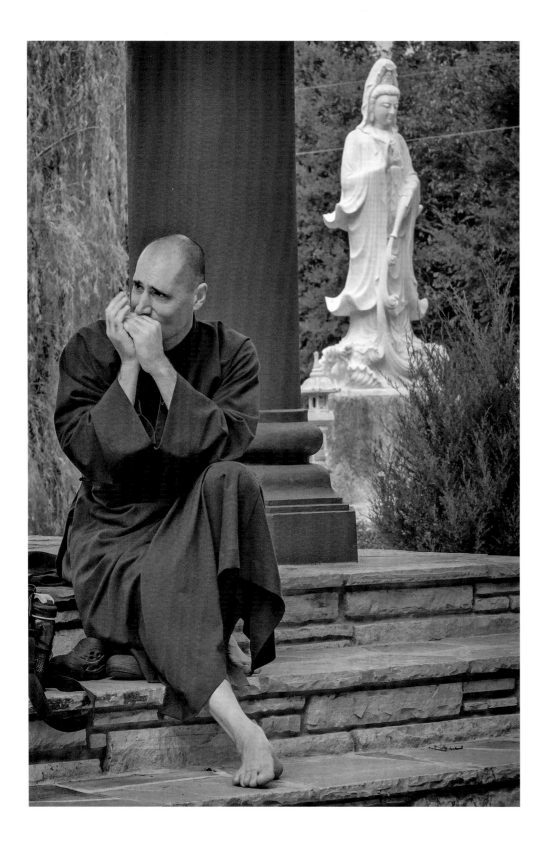

Live your daily life in a way that you never lose yourself. When you are carried away with your worries, fears, cravings, anger, and desire, you lose yourself. The practice is always to come back home to yourself.

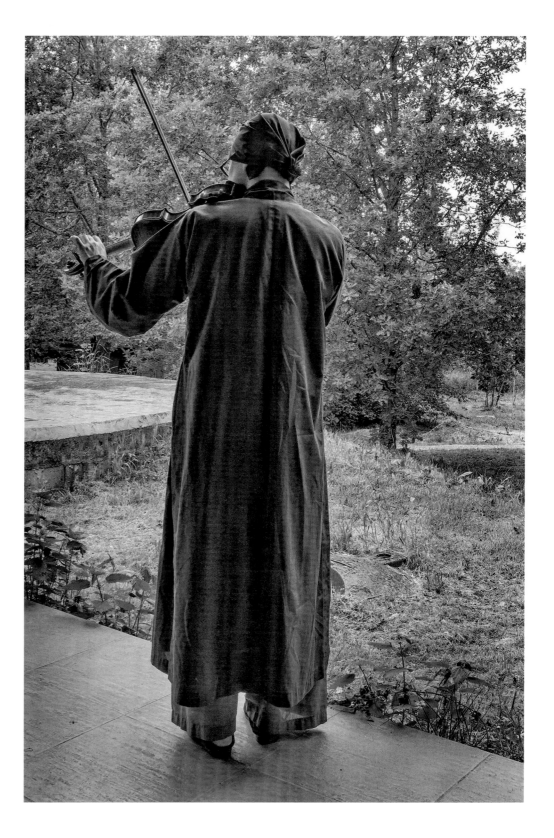

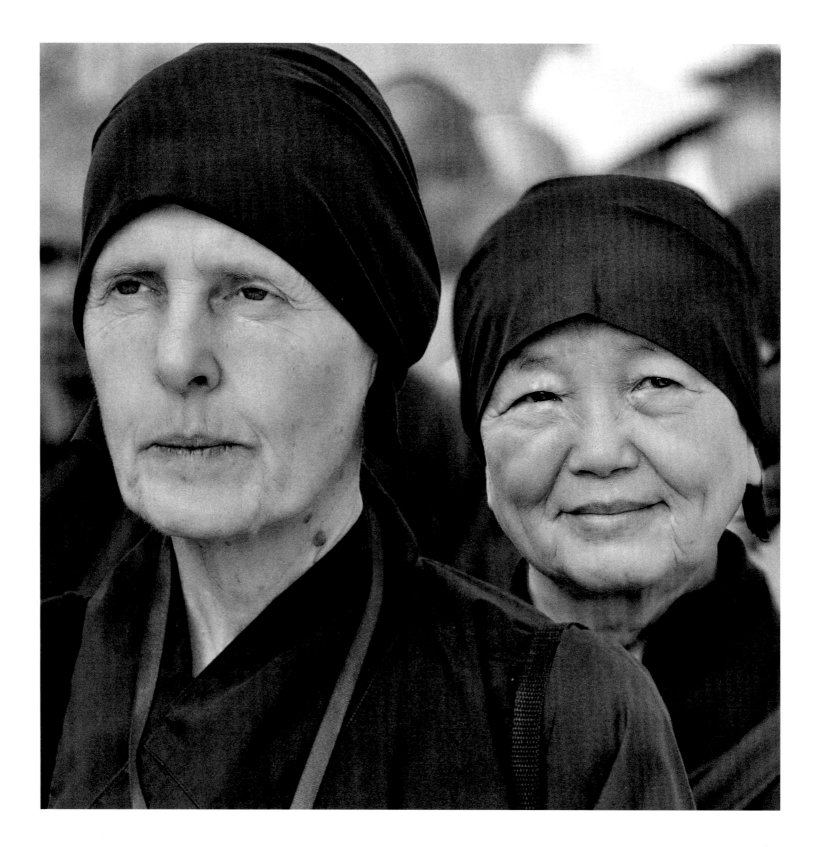

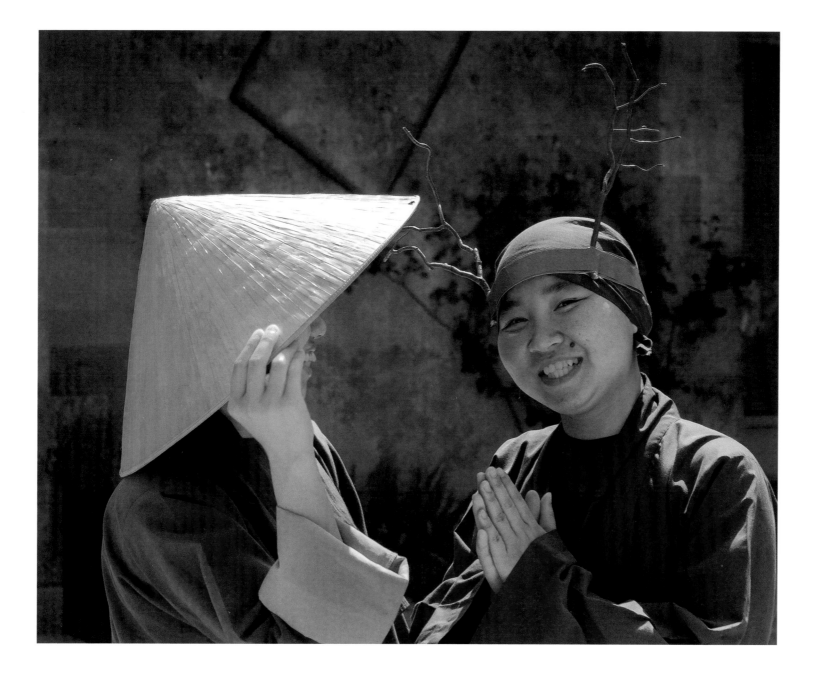

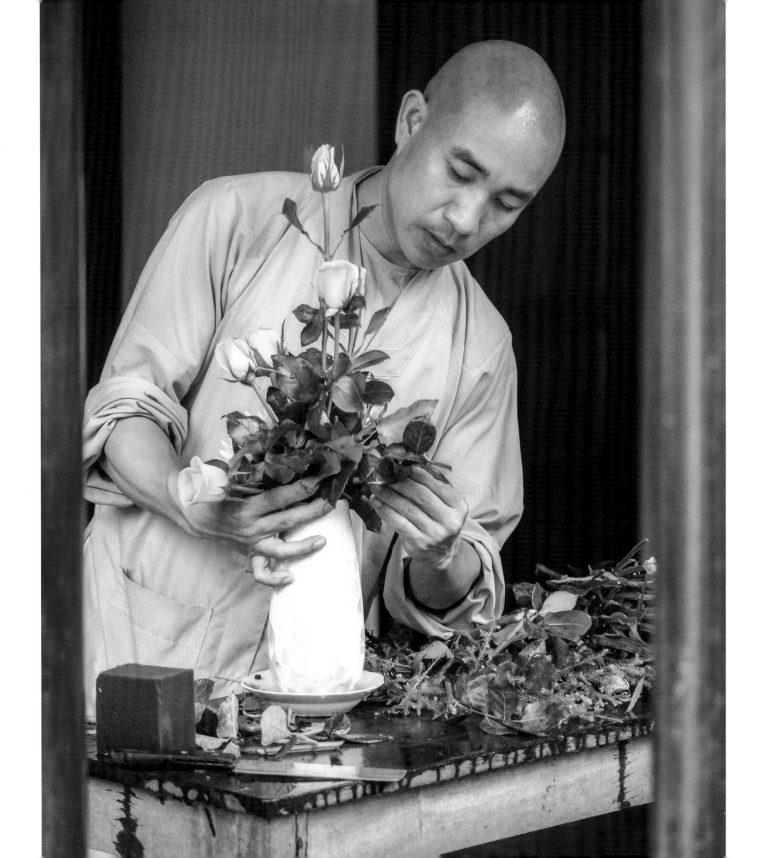

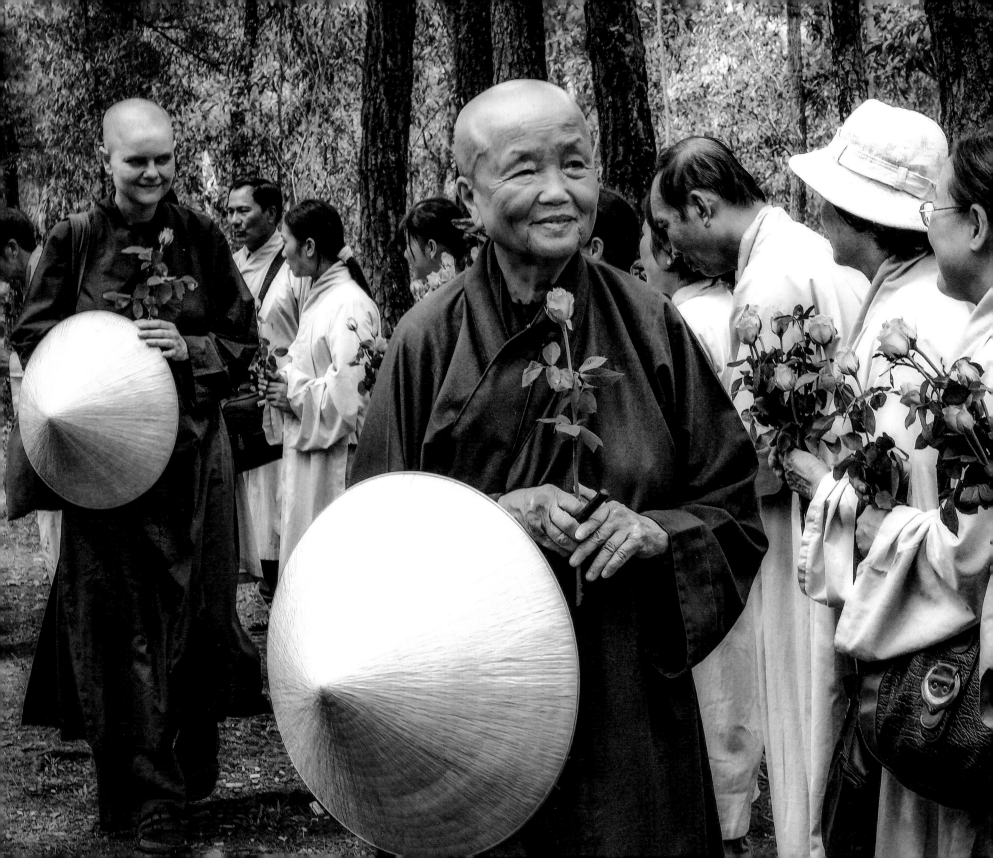

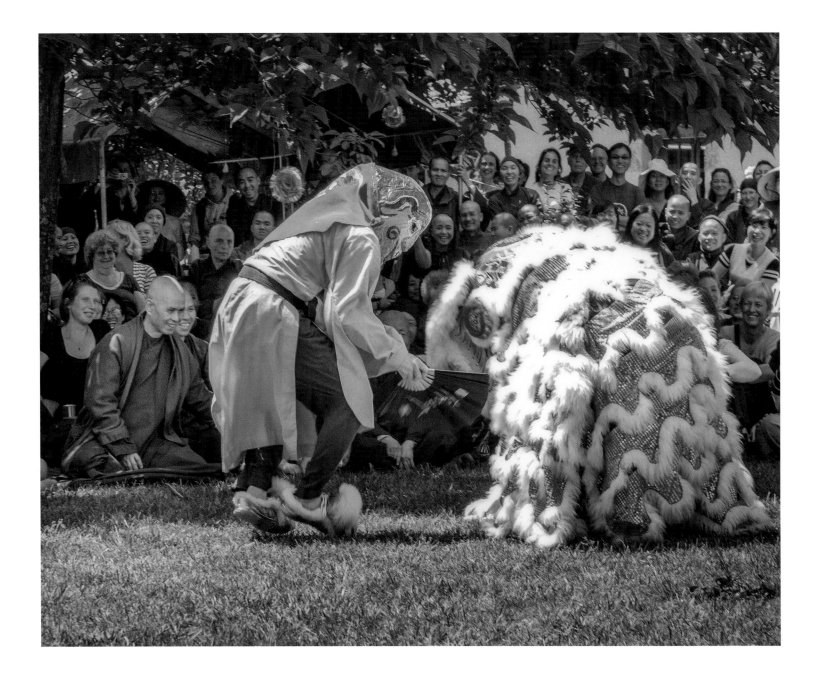

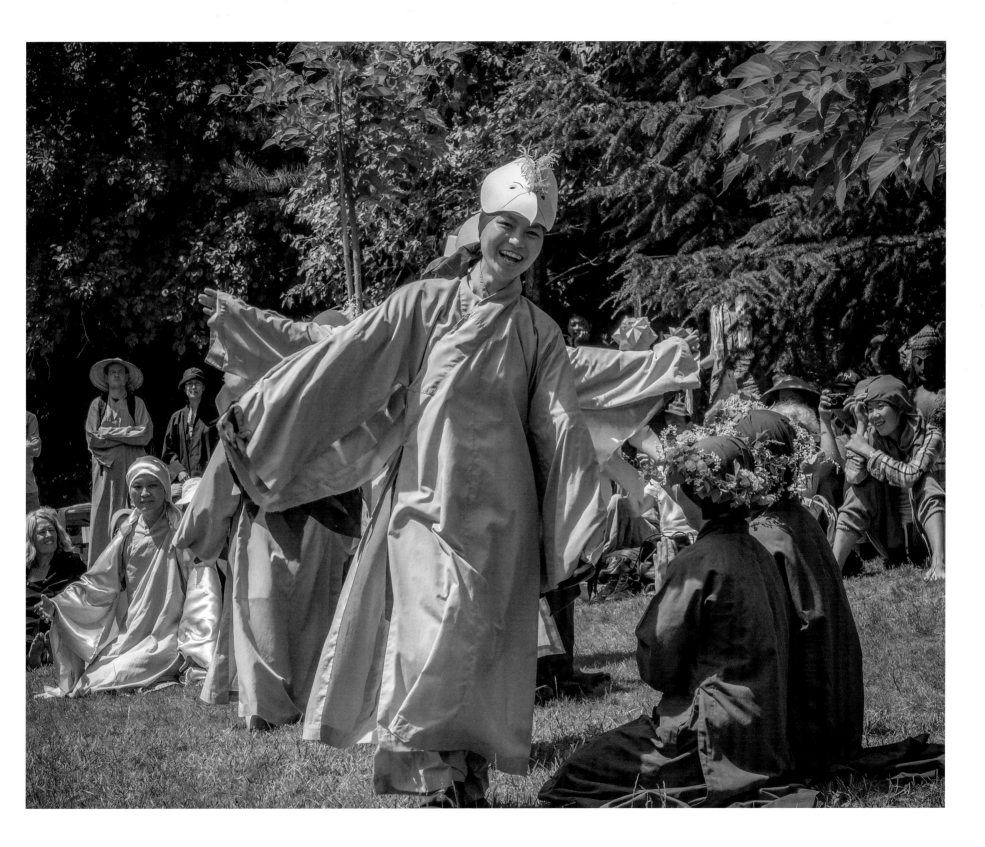

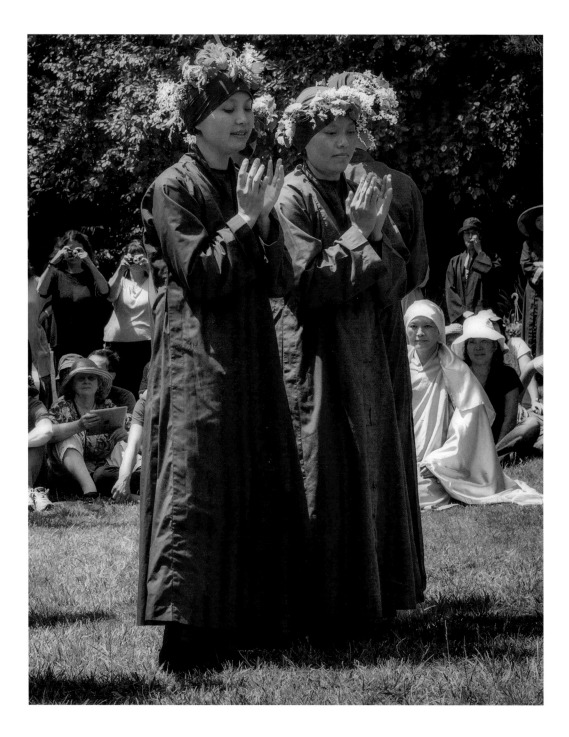

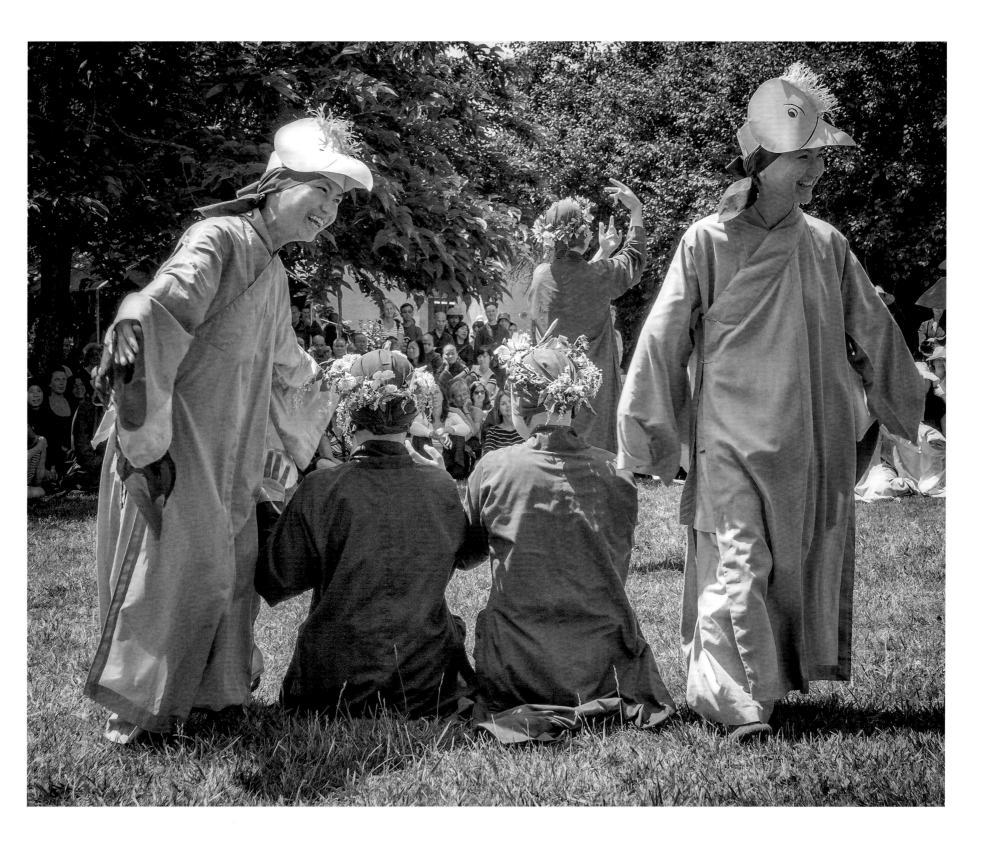

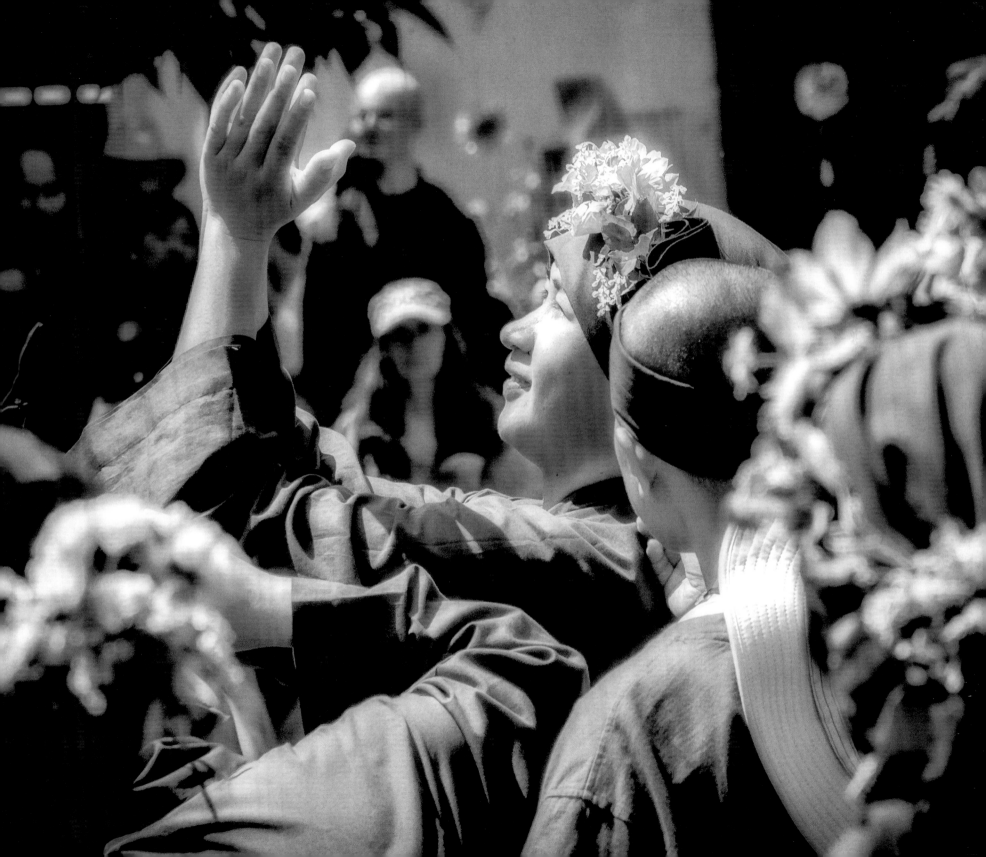

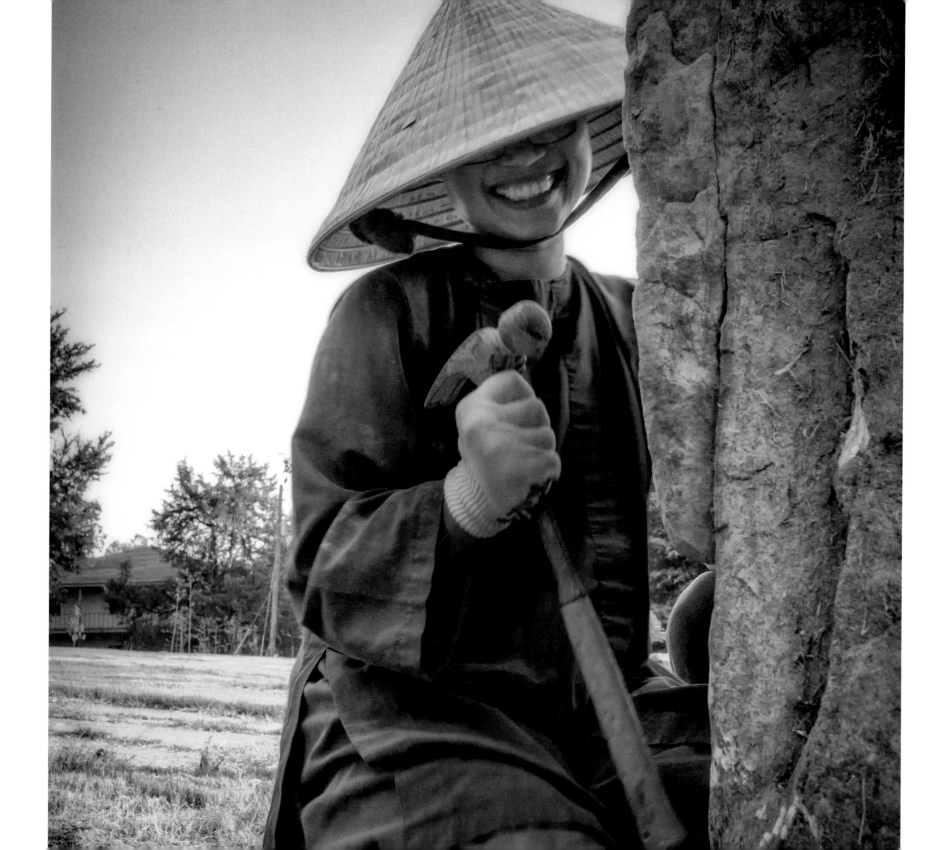

If we are peaceful, if we are happy,
we can smile and blossom like a flower,
and everyone in our family, our entire society,
will benefit from our peace.

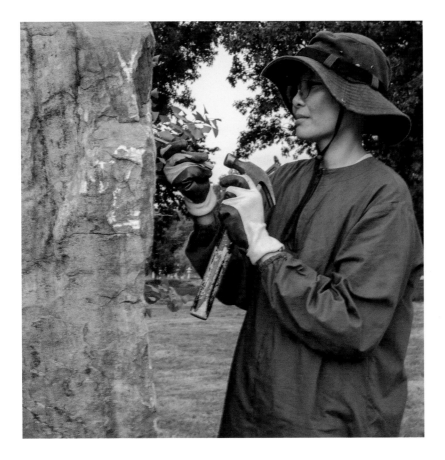

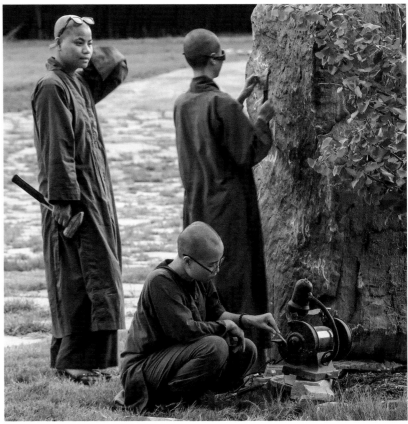

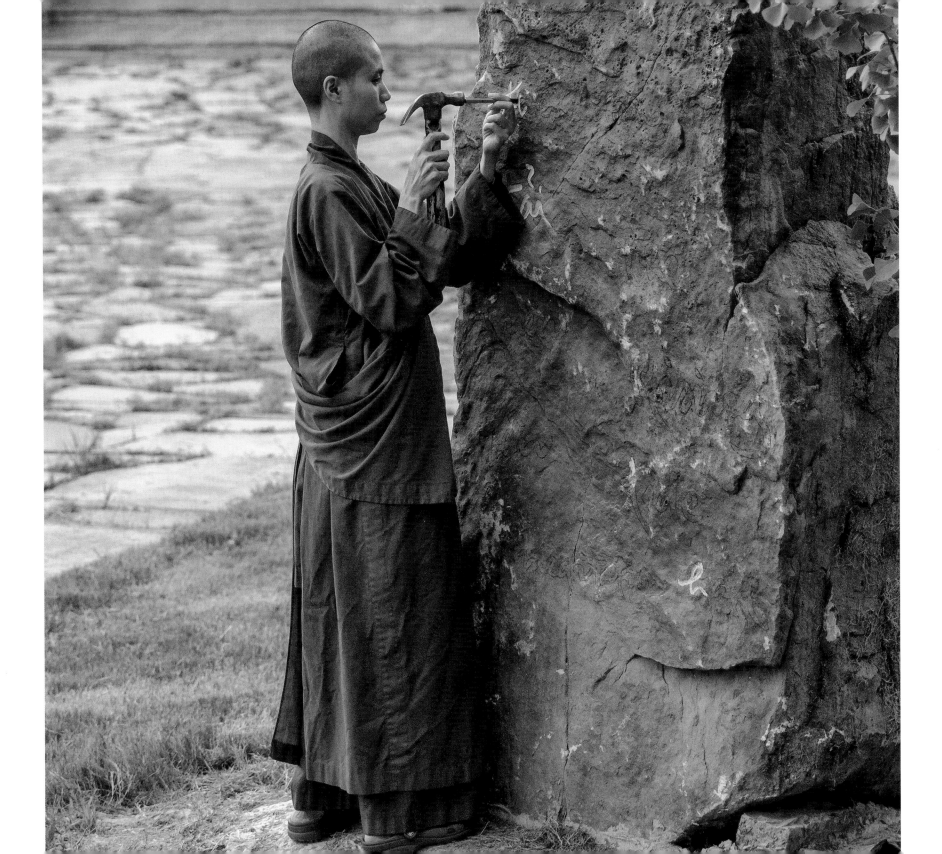

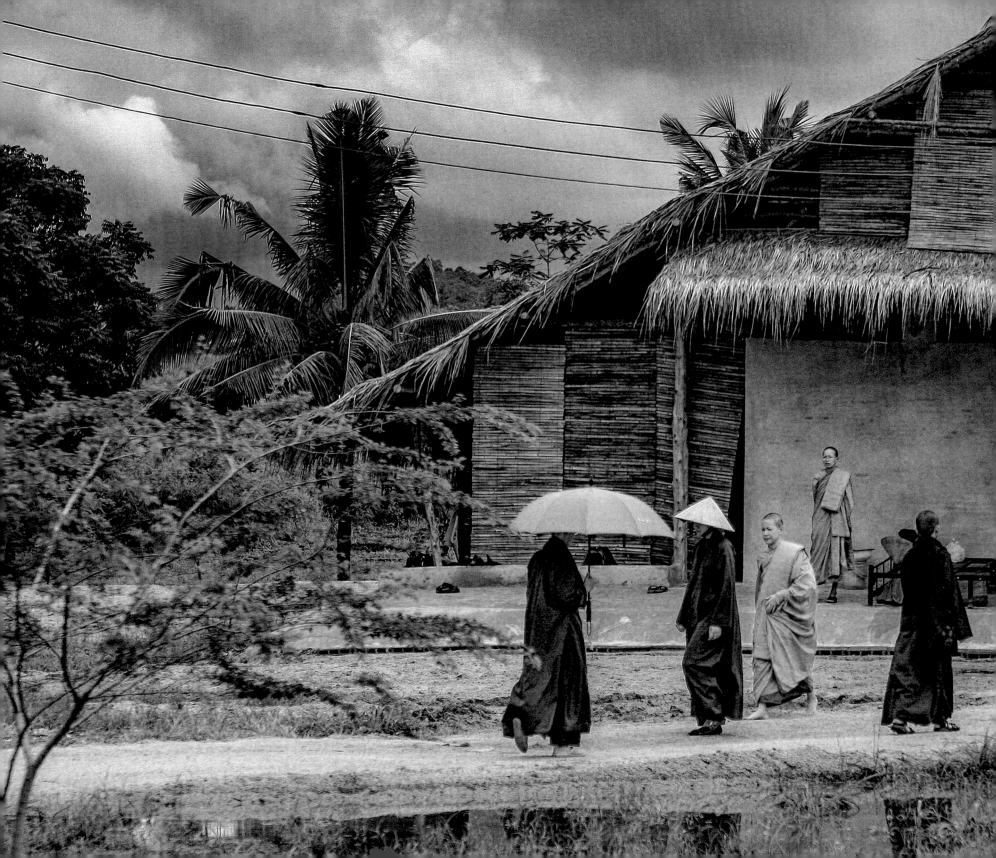

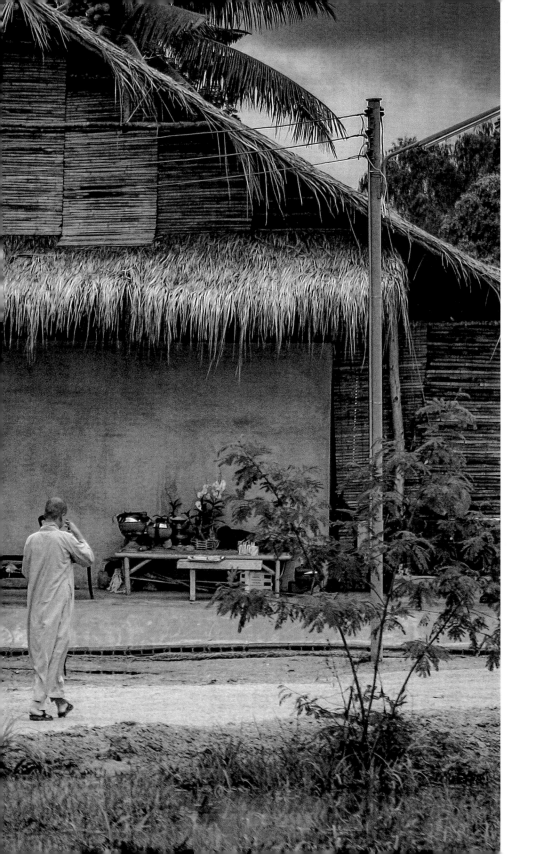

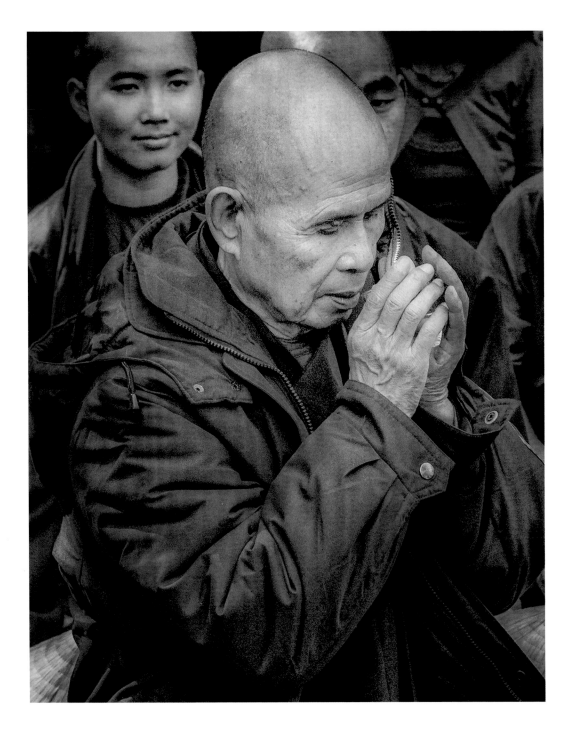

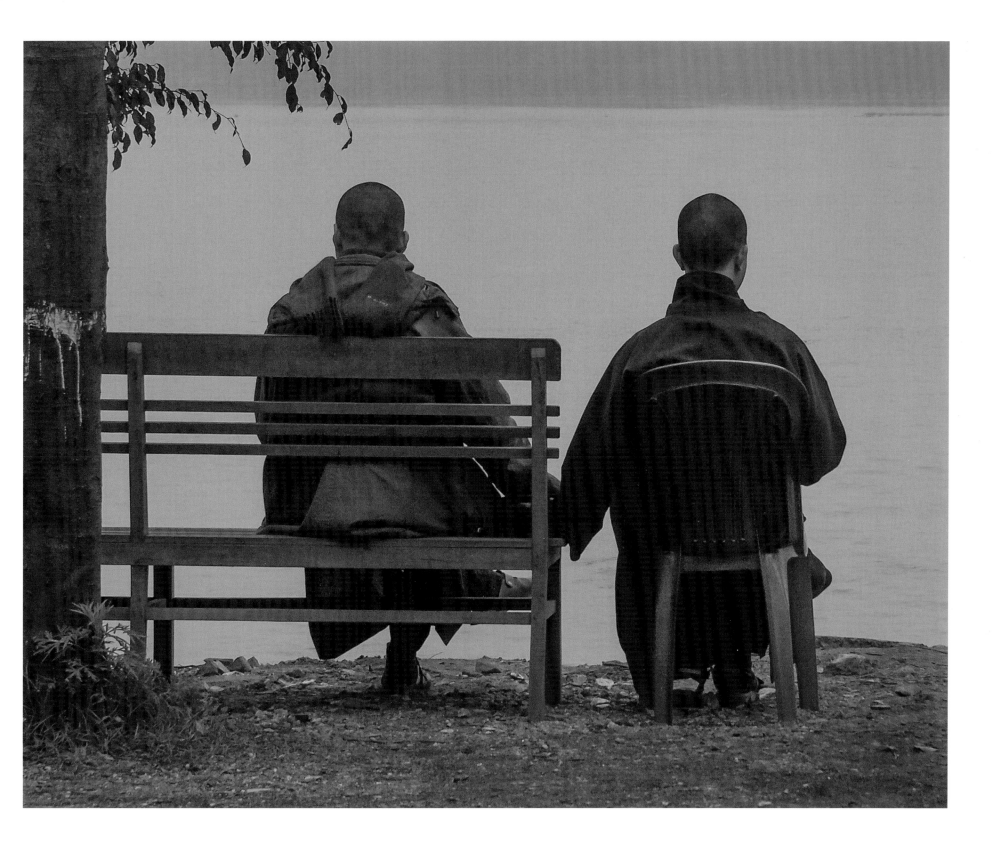

PHOTO INDEX

Monastics and laypeople practice the art of mindful living in the tradition of Thich Nhat Hanh at retreat communities worldwide. To reach any of these communities, or for information about individuals and families joining for a practice period, please contact:

Plum Village
13 Martineau
33580 Dieulivol, France
plumvillage.org

Blue Cliff Monastery
3 Mindfulness Road
Pine Bush, NY 12566
bluecliffmonastery.org

Magnolia Grove Monastery
123 Towles Road
Batesville, MS 38606
magnoliagrovemonastery.org

Deer Park Monastery
2499 Melru Lane
Escondido, CA 92026
deerparkmonastery.org

The Mindfulness Bell, a journal of the art of mindful living in the tradition of Thich Nhat Hanh, is published three times a year by Plum Village.

To subscribe or to see the worldwide directory of Sanghas, visit **mindfulnessbell.org**.

A portion of the proceeds from your book purchase supports Thich Nhat Hanh's peace work and mindfulness teachings around the world. For more information on how you can help, visit www.thichnhathanhfoundation.org. Thank you.

PARALLAX PRESS

Parallax Press is a nonprofit publisher, founded and inspired by
Zen Master Thich Nhat Hanh. We publish books on mindfulness in
daily life and are committed to making these teachings accessible to
everyone and preserving them for future generations. We do this work
to alleviate suffering and contribute to a more just and joyful world.

For a copy of the catalog, please contact:
Parallax Press
P.O. Box 7355
Berkeley, CA 94707
Tel: (510) 540-6411
parallax.org